MASTER PAINTINGS

The Phillips Collection

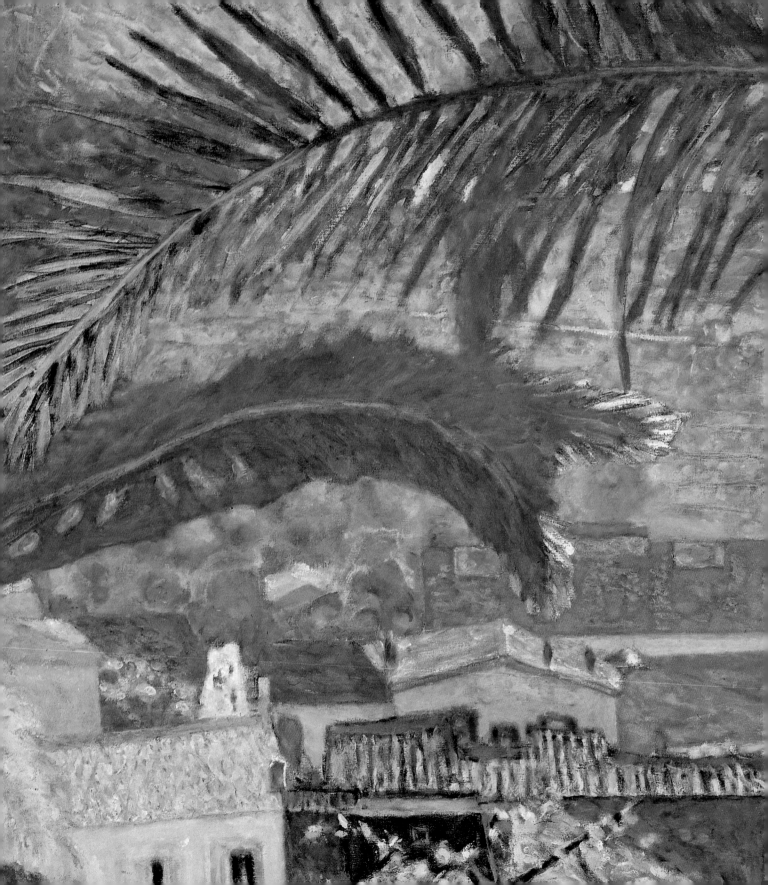

MASTER PAINTINGS

The Phillips Collection

COUNTERPOINT

IN ASSOCIATION WITH THE PHILLIPS COLLECTION, WASHINGTON, D.C.

Library of Congress Cataloging-in-Publication Data

Phillips Collection.
Master paintings : The Phillips Collection.
Includes bibliographical references.
1. Painting, Modern—19th century—Catalogs. 2. Painting, Modern—20th century—Catalogs. 3. Painting—Washington (D.C.)—Catalogs.
4. Phillips Collection—Catalogs. 5. Phillips Collection. I. Title.
ND189.P47 1998
750'.74'753—dc21 98-10763

ISBN 1-887178-78-3 (alk. paper)

COVER: Henri Matisse, *Interior with Egyptian Curtain* (detail), 1948. See page 142.
FRONTISPIECE: Pierre Bonnard, *The Palm* (detail), 1926. See page 28.

Design and composition by Wilsted & Taylor Publishing Services.
Publication coordinated by Carole McCurdy.
Printed in Italy by Amilcare Pizzi S.p.A. on acid-free paper that meets the American National Standards Institute Z39-48 Standard.

COUNTERPOINT
P.O. Box 65793
Washington, D.C. 20035-5793

Counterpoint is a member of the Perseus Books Group.

1 3 5 7 9 8 6 4 2

FIRST PRINTING

CONTENTS

PREFACE

Eliza E. Rathbone

This selection of 106 outstanding works from the permanent collection was made with a desire to include as many major paintings as possible and at the same time to reflect the breadth of the collection. Many of the works chosen are on constant view. Works on paper, however, must be protected from prolonged exposure to light. Other major works are occasionally not on view because of loans to special exhibitions elsewhere.

Each painting in this book is accompanied by a quotation. Most often the artist's own words offer insight into the creative process, attitude, or philosophy involved in a given work. Occasionally the most eloquent words come from another artist: Hartley on Ryder, de Chirico on Morandi, or Rothko on Avery. Their observations drive home the concept of artistic dialogue so central to Duncan Phillips's presentation of art in this museum. The voice of Duncan Phillips himself comes through in various quotes that demonstrate his keen perceptions as well as his passion for art. Phillips's strong sense of each artist as a unique individual with a highly personal motivation was eloquently expressed in many of his own books and essays, including one fittingly titled *The Artist Sees Differently*. We hope that the quotations that accompany each painting will provide a window into the world of the artist and that the reader will find a revealing resonance in words such as Rothko's about Avery's "domestic, unheroic cast" or Chase's advice to carry a picture "well out to the edge"; Hartley's evocation of "the great intangible" and Guy de Maupassant's description of Monet lying "in wait for the sun and shadows, capturing in a few brushstrokes the ray that fell or the cloud that passed."

I would like to acknowledge the many members of the staff who have contributed to this publication. The initial selection of images was primarily made by former director Charles S. Moffett, curator Elizabeth Hutton Turner, and myself. A team from the curatorial department researched most of the quotations, and in this regard I would like to thank especially Donna McKee, Stephen Phillips, Katy Rothkopf, Karen Schneider, Elsa Mezvinsky Smithgall, Lisa Portnoy Stein, Beth Turner, and Suzanne Wright. I would also like to thank Lisa Zarrow for handling all the issues arising from the reproduction of the works and for her exacting standard throughout the color proofing process. Thanks are also due to Thora Colot, Erika Passantino, Sarah Martin, and Anne Norton Craner. It is always a pleasure to work with Carole McCurdy of Counterpoint and we are grateful to Christine Taylor for her design. This publication is greatly enhanced by the contributions of Laughlin Phillips and Robert Hughes. Finally, I would like to offer heartfelt thanks to Allison Freeman for the time, energy, and dedication that she has so generously given to this project.

FOREWORD

Laughlin Phillips

Late in the fall of 1921, two large rooms of an 1897 brownstone house near Dupont Circle were quietly opened to the public of Washington, D.C. On the walls were French paintings by Chardin, Monet, Sisley, Monticelli, and Fantin-Latour. Along with them were paintings by the contemporary Americans Twachtman, Weir, Ryder, Davies, Whistler, Lawson, Luks, and Hassam.

Although there was no press conference, or champagne lunch, or reception, this was the opening of The Phillips Memorial Art Gallery, now known as The Phillips Collection. Incorporated in the District of Columbia in July 1920 as a foundation specializing in the display of art, it was the first museum in the United States to emphasize the work of living artists.

In the other rooms of the Victorian house lived the Gallery's founder, Duncan Phillips, aged thirty-five; his mother; and his wife of just a few weeks, Marjorie Acker Phillips, a painter herself, who had studied at the Art Students League of New York. For the next several years, the exhibition rooms were open to the public from 2 to 6 P.M. on Tuesdays, Saturdays, and Sundays.

Today the Collection has grown into one of the world's most loved and respected small museums. With holdings of more than two thousand works of art, including some of the finest works of nineteenth- and twentieth-century French and American artists, the Collection now occupies all of the original house,

along with the Goh Annex, opened in 1989. It maintains an increasingly active program of exhibitions, concerts, publications, and loans to special exhibitions organized by other museums. During its entire history the Collection has held to its unique philosophy of showing paintings in a comfortable domestic setting, so that "visitors [would] feel at home in the midst of beautiful things and [be] subconsciously stimulated while consciously rested and refreshed."[1]

Any attempt to understand the establishment and growth of this extraordinary museum must focus directly on the background and philosophy of its founder, my father, Duncan Phillips. Though the Collection was assembled for public appreciation, it has a uniquely personal stamp on it. Until his death in 1966, my father made all decisions about purchases and exhibitions without resort to professional advisors or concern for the dictates of contemporary taste. The only person who participated in all aspects of the Collection's development was my mother, Marjorie Phillips, whose opinion was sought before any painting was acquired.

Duncan Phillips was born in Pittsburgh, Pennsylvania, in 1886, the grandson of James Laughlin, a banker and co-founder of the Jones and Laughlin Steel Company. Laughlin's daughter, Eliza, and her

1. From the Minutes of the First Annual Meeting of Trustees of the Phillips Memorial Art Gallery, 1921.

husband, Major Duncan Clinch Phillips, a business-man, lived in a high-ceilinged house full of academic European and American paintings. As my father wrote after he had founded the Collection:

"Looking back on my childhood in that house, I do not remember the pictures.... And yet the long and stately drawing-room contained oil paintings and many of them—'Hudson River School' landscapes and well-drawn storytelling European pictures—in gorgeous gold frames. I was constantly aware of them and more or less fascinated, but none too pleasantly."[2]

In 1896, after the retirement of Duncan's father and the death of his grandmother, the Phillips family moved to Washington, persuaded that it had a better climate than Pittsburgh. They bought property at Twenty-first and Q Streets, Northwest, and commissioned the noted Washington architects Hornblower and Marshall to design a house in the Georgian Revival style. (This building, with additions built in 1907, 1920, 1923, 1960, and 1984, now houses The Phillips Collection.)

My father and his brother James, two years older, went to Washington schools, including the Washington School for Boys. While there, in 1901, Duncan wrote to his mother, "The one study in which my interest, enthusiasm, and ambition is kept alive is English. And as for composition writing, I cannot find out the reason for my passionate fondness for this occupation."[3]

Entering Yale in 1904, Duncan studied English and agitated for more courses on the history of art. In an article entitled "The Need for Art at Yale," in the June 1907 issue of the *Yale Literary Magazine*, he wrote:

"A thing that strikes the outsider as strange in our college curriculum here is that so many splendid courses with celebrated instructors should be offered to the dilettante in literature—while the sister art of painting now receives no attention save in technical instruction to the art students."

After graduating from Yale in 1908, my father became increasingly involved in writing about art. In a letter to his class secretary, he reported: "I have lived in my home in Washington ... devoting much study to the technique of painting and history of art.... At Madrid, London, and Paris as well as New York and other cities, I have met and talked with many artists in their studios and gone the round of exhibitions. [In my writing] I have attempted to act as interpreter and navigator between the public and the pictures, and to emphasize the function of the arts as a means for enhancing and enriching living."[4]

This ambition—to act as a sensitive and eloquent interpreter of the painter's language and to share his own delighted understanding of art with an ever-growing audience—became my father's dominant concern, and his life work. In 1918, following a personal bereavement, this interest began to take concrete form in the establishment of the Collection as a place where the public could meet and appreciate great art in a quiet and informal setting. Emerging from a period of deep shock after the death of his father in 1917 and his brother James a year later, Phillips conceived the idea of a memorial gallery: "I would create a Collection of pictures—laying every block in its place with a vision of the whole exactly as the artist builds his monument or his decoration ... a joy-giving, life-enhancing influence, assisting people to see beautifully as true artists see."[5]

The Phillips Memorial Gallery was created at the

2. Duncan Phillips, *A Collection in the Making* (New York: E. Weyhe, 1926), p. 3.

3. Letter quoted in *Duncan Phillips and His Collection* (Boston: Little, Brown, 1970), p. 34.

4. Letter quoted by Marjorie Phillips in *Duncan Phillips and His Collection*, p. 39.

5. Duncan Phillips, *A Collection in the Making*, p. 4.

end of 1918, incorporated as a District of Columbia foundation in 1920, and opened to the public in the fall of 1921. Starting with a small, private family collection, my father had, by the time of the public opening, acquired some 240 paintings.

The paintings originally purchased, and all those to follow, were chosen not necessarily because they were widely acclaimed, historically significant, or radically innovative, but because they impressed my father as beautiful products of a particular artist's unique vision. His increasingly catholic taste excluded the academic and faddist, but honored "the lonely artist in quest of beauty, the artist backed by no political influence or professional organization."

His collecting proceeded at a wild and wonderful pace during those early years. The Renoir masterpiece *Luncheon of the Boating Party* was acquired in 1923, Daumier's *The Uprising* and Cézanne's *Mont Sainte-Victoire* in 1925. By 1930, there were more than six hundred paintings in the Collection, indicating a growth of some forty paintings a year. This, however, does not reveal the collector's full activity, since dozens of paintings acquired in those early years were later traded back to various artists and dealers for what he considered better examples of a given artist's work. Other paintings were simply disposed of when they failed to pass muster. As Phillips wrote in a published 1921 inventory: "It has been my policy, and I recommend it to my successors, to purchase spontaneously and thus to make mistakes, but to correct them as time goes on. All new pictures in the Collection are on trial, and must prove their powers of endurance."

The paintings reproduced in this book represent an excellent sampling of the finest works in the Collection. This selection cannot, however, reveal one of my father's favorite museum techniques—to create "exhibition units" of paintings by each of his favorite artists. Thus, the Collection today includes units of paintings by Bonnard, Cézanne, Braque, Daumier, Rouault, Kokoschka, Klee, Ryder, Prendergast, Tack, Dove, Marin, Knaths, and Rothko. Sometimes these exhibition units have been hung in rooms of their own; more often, they have been mixed with the "really good things of all periods ... with such a delightful result that we recognize the universality of art and the special affinities of artists."[6]

In some cases major groups of paintings were formed when my father became a friend and patron of contemporary artists whose work he particularly admired. This was especially true of Augustus Tack, Arthur Dove, and Karl Knaths, all of whom received vital support and encouragement from him at crucial periods of their lives.

The Collection also includes a great many works bought by my father to encourage talented but little-known artists. This "encouragement collection" grew at an especially rapid rate during the 1930s, when the museum ran a small art school and when my father served as a regional chairman of the New Deal's Public Works of Art Project.

Inevitably, as the Collection grew, the problem of exhibition space became more acute. In 1930, our family moved out of the Twenty-first Street house so that all of it could be converted to museum use. And in 1960 an extensive wing was added to provide new and safer space in which to present the most important holdings.

By the time Duncan Phillips died in 1966, he had turned the Collection into a magnificent living memorial—not only to his father and brother, but to the independent, creative spirit of the many hundred artists represented there. With its great variety of vital, nonacademic paintings—many of them masterpieces—chosen by a single inspired art lover and ex-

6. Duncan Phillips, *A Collection in the Making*, p. 7.

hibited in an unpretentious domestic setting, the Collection became a favorite small museum, a private place to revisit on trips to Washington and to introduce to good friends.

Shortly before his death, my father prepared "A Statement of My Wish for the Future of The Phillips Collection." He wrote that the Collection has "in recent years attained to its essential character as a home for a wide diversity of paintings, with a unity in all the diversity," and that "this intimate, personal creation, this creative conception having been achieved, it must in the future be maintained." However, he went on: "This does not mean that the Collection should be closed. It must be kept vital, as it always has been, as a place for enlightenment, for enjoyment, for rediscovery—by frequent rearrangements of the collection, and by the enrichments of new acquisitions." He went on to urge the continued display of exhibition units and special loan shows, together with the series of free Sunday afternoon concerts initiated in 1941.

Responding to another of his wishes, my mother became Director in 1966. In addition to carrying on an active program of acquisitions and special exhibitions, she celebrated the Collection's fiftieth anniversary in 1971 by organizing a superb Cézanne loan exhibition and by writing the book *Duncan Phillips and His Collection*, full of personal reminiscences about the museum and its founder.

After I took over in 1972, upon my mother's retirement, it soon became apparent that the physical, financial, and professional health of the Collection would require resources far beyond those which could much longer be provided by its endowment or by the Phillips family alone. Accordingly, in 1979 we launched a multi-year program to restore and somewhat enlarge the museum buildings, conserve its works of art, professionalize and expand the rudimentary staff, do more research on the collection, and make it more ac-

cessible to the public. At the same time, we began to expand the board of trustees, form advisory and membership organizations, conduct fundraising campaigns, and generally convert what was once a family-controlled museum into one with a broad base of public support and direction. All of this was to be done without losing the museum's unique, intimate character.

As I write this, nineteen years later, much has been accomplished. Major renovations of the original building were completed in 1984; and by 1989 we had rebuilt and considerably expanded the 1960 annex. When I retired as director in 1992, the professionalism of the Collection's staff and operations made it possible to enlist Charles S. Moffett, an eminent curator of impressionist and post-impressionist art, as our first non-family director. Very recently he was succeeded by Jay Gates, whose extensive experience has included the direction of other important museums of art.

Needless to say, much remains to be accomplished, particularly in attaining the degree of financial security that an art collection of this importance deserves. We also hope in the coming years to develop the Collection's education programs into a center for the study and appreciation of modern art.

Throughout this process, we have been extremely grateful for the extraordinary support that the residents, foundations, and corporations of Washington and the nation as a whole have provided. I am sure that Duncan Phillips would be astonished at how his vision has been recognized and his generosity repaid. The Collection will continue to celebrate adventurous, independent visual expression; to show how art of this sort is always modern; and to present that art in a warm setting for the viewer's pleasure and understanding.

ART AND INTIMACY

Robert Hughes

Everyone who loves early modern art loves The Phillips Collection and envies Washington for having it. The neo-Georgian pile at Twenty-first and Q Streets has grown since the Edwardian days when it was the boyhood home of its founder, Duncan Phillips, who died in 1966. Parts were tacked onto it to fit its ever-growing collection in 1907, 1920, 1923, 1960, and 1984. With the 1989 opening of the Goh Annex, it reached the limit of its expansion. And yet The Phillips has never lost its aedicular quality, its gift of intimacy and unhurried ease in the presence of serious art. Nobody ever feels pressured there or cheated by inflated expectation. It was not made for people with a viewing speed of three miles per hour.

Which is a near-miracle, considering what has happened in some of the great encyclopedic museums of America, like the National Gallery in Washington or the Metropolitan in New York. Unable to handle the vast art audience they helped create, big American museums in the 1980s became, in effect, mass media in their own right. The audience is now too big for the art.

But art does not like a mass audience. Only so many eyes can take in the same painting at the same time. There is a level of crowding beyond which one's sense of the object simply dies. Of course, there are plenty of areas in the big American museums where works of art still can be enjoyed in the silence and rela-

tive intimacy that is their due. Only on special occasions do they attain the cultural obscenity of the Louvre or the Uffizi in high tourist season. But the miseries of art-as-mass-spectacle are here, and will not go away.

In contrast are the oases, small and well-loved museums whose scale feels right, where the eye is not crowded and the size of the public does not threaten to burst the institutional seams. They evoke, above all, loyalty and affection. In America, one thinks of the Frick, in New York, with its sublime collection whose unchanging nature one no more resents than the fixity of the North Star, and of The Phillips Collection, which is to early modernism what the Frick is to old masters.

Duncan Phillips knew what he wanted: He saw where the big museums were heading. "It is worthwhile," he presciently wrote almost eighty years ago, "to reverse the usual process of popularizing an art gallery. Instead of the academic grandeur of marble halls and stairways and miles of chairless spaces, with low standards and popular attractions to draw the crowds . . . we plan to try the effect of domestic architecture, of rooms small or at least livable, and of such an intimate, attractive atmosphere as we associate with a beautiful home."

The Phillips Collection has changed since its founder's death: How could it not, without dying,

too? It is bigger, by nearly nineteen thousand square feet, and puts more stress on conservation and education. It holds focused historical surveys and one-person shows, samplings rather than full retrospectives. But over all this broods continuity. Duncan Phillips's ghost still stalks the corridors of his museum like a benign, bony wading bird. No one would lightly abandon the values he implanted there.

The style was the man. Duncan Phillips was born into a family of Scots descent, which had made its fortune in Pittsburgh in banking and steel. From his tubular tweeds to his innate belief in the obligations of public service, he was the quintessential eastern WASP. He was brought up in Washington among Tafts and Glovers, and studied English literature at Yale. He was well traveled, rich but not filthy rich, and pomp embarrassed him. He did not collect for "status," because modern art conferred none in Washington seventy years ago, and, in any case, he felt no social insecurities. Still less did he collect for investment, though he had no qualms about selling works out of the collection to trade up.

Like a good Scot, he eschewed the pleasures of the table. When in Paris with his artist wife Marjorie—his equal partner in forming the collection—he would sit down to lunch in temples of belle epoque cooking like the Tour d'Argent and stubbornly order two poached eggs and a morsel of bread pudding. His digestion, he said, had been done in by too many hot dogs at Yale.

But Yale had also formed his ambition—as it would for another great Washington collector who was there in 1907, Paul Mellon. Phillips was struck by the "deplorable ignorance and indifference" to art among the students who would move into America's elite. One graduate student he knew declared at dinner that "Botticelli is a wine, a good deal like Chianti only lighter. . . . He was rudely awakened by a sensitive

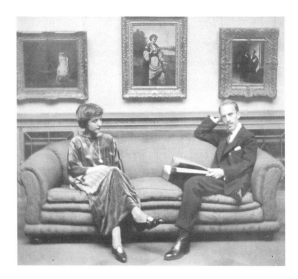

Marjorie and Duncan Phillips seated in the Main Gallery,
Phillips Memorial Gallery, ca. 1922.
Photograph by Clara E. Sipprel.

friend to the fact that Botticelli is not a wine but a cheese." Phillips was horrified, as Alfred Barr also would be, by the lack of art history courses in American schools. (What he would have made of the immense, academized, turgid structure of American art education today is anyone's guess.) He wanted to be a dilettante, in the full and proper sense of the word: not a superficial amateur, but a man who took educated pleasure in every field of culture, especially art.

The clue to this growth lay in the writings of Walter Pater, who was as much a cult figure among American student aesthetes at the turn of the century as John Ruskin had been twenty years before or Clement Greenberg would be in the 1960s. Pater's coiling, elegantly nuanced descriptions of works of art, his craving for the exquisite, and above all his belief that the aesthete, "burning with a hard and gem-like flame," could transcend the grossness of material society,

Main Gallery, 1927.

struck deep into the intellectual values of young Duncan Phillips's time and class.

Like many others, including Bernard Berenson and the French critic Henri Focillon, Phillips came to believe that works of art transcend the immediate social and historical conditions of their making, that they form a universal language that can speak to attuned people in any time and place because they are triggers for emotions and feelings that lie deeper than socioeconomic conditioning. Hence their power to please, elevate, stimulate, and provoke reflection. Contemplating them, the viewer becomes a kind of artist.

As Duncan Phillips put it, art is "a joy-giving, life-enhancing influence, assisting people to see beautifully as true artists see." This vision of the "life-enhancing" powers of art was Pater's main legacy to American aesthetes between 1880 and 1914. "Mere" delight—Phillips would never have called it "mere," for it was part of his raison d'être, as it is with all authentic connoisseurs—is out of intellectual fashion today, derided by neo-Marxists and post-structural-

ists as one of the masks behind which an elite goes about its work of repression.

To art historians who cannot lay eyes on a Matisse still life without spinning lengthy footnotes on the gender-based division of labor in the Nice fruit market in 1931, Duncan Phillips's kind of aestheticism is a fossil. Phillips himself never denied that art reflects society; he knew their reciprocity—as his enthusiasm for Daumier, among others, showed. But he always put disinterested aesthetic awareness before the work of decoding art as a social text. And who could deny that his beliefs have brought more people closer to firsthand art experience than all the socioaesthetic jargon of recent years?

"Life-enhancement" could oppose itself to death and loss. The collection began, in fact, as the Phillips Memorial Art Gallery, a work of pietàs—a Roman sense of family obligation—to the memory of his father and, especially, his older brother James, who had died at age thirty-four in the Spanish flu epidemic of 1918. Duncan and James had collected pictures jointly until then, and James's death, Duncan wrote later, "forced my hand":

"There came a time when sorrow almost overwhelmed me. Then I turned to my love of painting for the will to live. Art offers two great gifts of emotion—the emotion of recognition and the emotion of escape. Both emotions take us out of the boundaries of self. . . . At my period of crisis I was prompted to create something which would express my awareness of life's returning joys. . . . I would create a collection of pictures—laying every block in place with a vision of the whole exactly as the artist builds his monument or his decoration."

Though born in grief, the collection would eschew the monumental: It would go in the family house and, symbolically, restore the life that house had lost. It

opened in three rooms of the Phillipses' home in 1921. Phillips's taste was daring, highly traditional, and somewhat idiosyncratic, all at once. Not for him the premade collection from the *menu touristique* of accepted values. His memorial to the dead was, above all, a product of reflection.

Duncan Phillips was not a "radical" even in his youth. In 1913, he wrote a review dismissing the New York Armory Show—the first North American exhibition of cubism, fauvism, impressionism, and post-impressionism—as "stupefying in its vulgarity" though later he repented of that, somewhat. Yet one should remember that, although the artists whose work Duncan and Marjorie Phillips collected from the 1920s to the 1950s are long since dead and have become excessively embalmed by history and the market, they were living, problematical creatures with a small audience then.

Few people in 1930 thought of Bonnard as a great painter; even as late as the 1950s there was no shortage of critics writing him off as a *retardataire* impressionist. If the collection now has sixteen Bonnards, it is because Duncan Phillips was almost alone in wanting Americans to see him in depth. But he was no Euro-snob. He stood up for Dove, Marin, Stieglitz, and other American modernists when few private collectors or museums would. His record of sympathy with the American avant-garde was far better than Alfred Barr's. Taste was policy. It was "a cardinal principle," he noted in 1922, "to make the gallery as American as possible, favouring native work whenever it is of really superior quality, as our painting unquestionably is."

Phillips clove to artists—Bonnard, Marin, Stieglitz, Dove—through studio vists and long correspondence. He was not moved by the snobbery that wants to rope in a star painter for the dinner party.

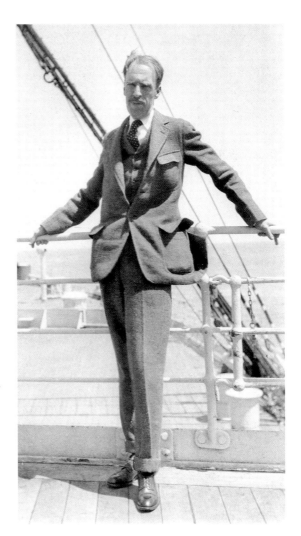

Duncan Phillips, shipboard on a transatlantic voyage, ca. 1920s.

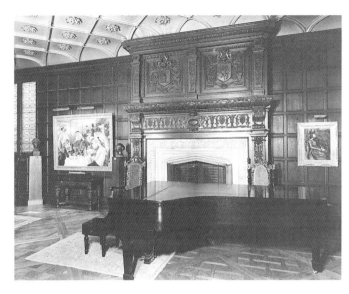

Music Room, site of the museum's Sunday afternoon concert series, ca. 1950s.

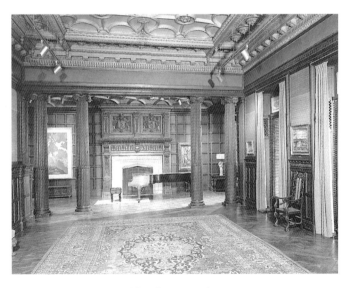

Music Room, ca. 1960s.

The art-star system hardly existed then. Phillips simply wanted to know more about art.

His closest relations were with Arthur Dove, whom he subsidized for some years: There are forty-eight Doves in The Phillips Collection and voluminous letters in the archive. Writing once of ancient Greek vase-painting, he mentioned "craftsmen who were also poets in their various plastic ways and who no doubt more truly resembled our modern artists than the great architects and sculptors of the time of Phidias." He thought of modern art as unpretentious in its essence.

Now that taste has been corrupted to the point where few can distinguish scale from size, and "important" means "unmanageably big," one is apt to lose sight of the fact that most of the paintings that changed art history between 1860 and 1950 would fit over a fireplace. Smallness, intimate address, helped distinguish focused art from the shameless inflation of the academy—as it needs to, once again, today.

Phillips knew this and was grateful to the artists who practiced it. With the new and the young, he was cautiously sympathetic. There being no market hysteria, he could wait, reflect, compare, and eventually admit the newcomer—Morris Louis, Kenneth Noland, Mark Rothko, or Philip Guston—to the company of Bonnard's *The Palm* and Matisse's *Studio, Quai St. Michel.* After all, it had taken him nineteen years to decide on his first Cézanne still life.

Lawrence Gowing wrote that "A succession of painters, passing through the capital, have learned in the collection the best lessons of their lives." True: The Phillips has always been an artists' museum. One may doubt whether Morris Louis's or Kenneth Noland's work would have turned out as it did without the radiant example of The Phillips's Bonnards.

When Richard Diebenkorn was a Marine at Quantico, he visited The Phillips Collection so regu-

larly that the powerful orthogonal framing of *Studio, Quai St. Michel* became the signature of his own work; so it is fitting that Diebenkorn's superb drawing show opened the Goh Annex forty-five years later.

When art-lovers talk about the paintings that have helped form their sense of quality, one is often struck to find how many hang in the collection. Did Gauguin ever paint a better still life than The Phillips's dusky-red smoked ham, its curve of creamy fat echoed by the sprout-ends of a scatter of pearly onions, floating on its iron table against a deep plane of orange wall? Is there a more audacious gesture anywhere in Bonnard's work than the wide arch of spiky foliage in *The Palm*? Or a Cézanne self-portrait more densely impacted with thought than the one Duncan Phillips bought in 1928 and told his registrar to grab and run with first if there was a fire? How many Matisses carry more messages for future art than his 1916 *Studio, Quai St. Michel*? Even those who don't greatly care for Renoir, finding much of his work sugary and repetitious beside the drier pictorial intelligence of a Degas—who is also beautifully represented in the collection—are likely to concur that *The Luncheon of the Boating Party*, painted in 1881 and purchased from Durand-Ruel in 1923 for $125,000, is one of the great paintings of the nineteenth century and the summit of Renoir's pictorial achievement.

This, in a sense, was the world's first museum of modern art, founded in 1921, eight years before the Museum of Modern Art opened its first show in a Manhattan brownstone. But only in a sense. The collection never set out to define a canon of modernism. It was much more an act of taste than a proposal about art history. What it stressed—and still insists on—is the continuity between past and present.

Phillips had no patience at all with "revolutionary" myths of the avant-garde. He sometimes thought in terms of evolution but was mildly skeptical of

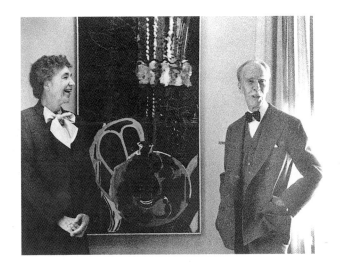

Marjorie and Duncan Phillips with The Philodendron (1952) *by Georges Braque, ca. 1954–55.*

Photograph by Naomi Savage.

progress in art. The eighteenth-century painter Jean-Baptiste Chardin, virtuoso of "the richly harmonious envelopment of objects in space," was the ancestor of Georges Braque's late still lifes of the 1930s and 1940s but not their "primitive" ancestor.

In its first stages, The Phillips Collection consisted largely of paintings by French artists like Chardin, Monet, Monticelli, Decamps, and Fantin-Latour, and American ones like Whistler, Ryder, Childe Hassam, Twachtman, and Luks. The six great Cézannes and three van Goghs, the matchless late Braques and the Matisses, the Bonnards and the hundreds of works by American modernists—Arthur Dove, John Marin, and so on to Mark Rothko and Philip Guston—would come later.

There are many works that seem to have no historical connection to modernism at all—some of them quite extraordinary, like Goya's *The Repentant St. Peter*

and the Delacroix portrait of the violinist Paganini, a tallowy wraith whose intensity seems, while you are looking at it, to disclose a whole vista of French Romanticism through the dark slot of its surface. Consequently, you never leave The Phillips feeling that a tour of "isms," that schematic labeling of successive movements on which the mass teaching of modern art has depended for the last fifty years, has been laid out for you. Instead, the clusters of images that come up in room after room have an implied but rarely argued coherence, a sense of "elective affinity" that leads you to ponder what they might have in common and, therefore, what the artists were actually thinking about.

The collection gathered in what Phillips called "units." From Twachtman to Nicolas de Staël, he liked to have blocks of five or six representative works by an artist. Then, on the wall, one painter could begin the silent *conversazione* with another. You watch the works talking. The place is set up for association and reverie. Its scholarship has always been impeccable, and Phillips himself was one of the best American

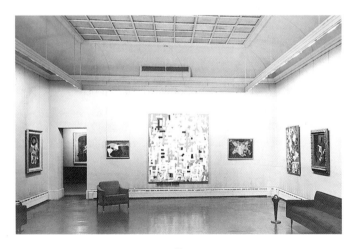

Main Gallery, 1963.

critics of his day. But the collection is more dedicated to correspondences and sympathies than to hard chains of art-historical cause and effect. And of course the collection gestures outward, to images it does not contain, to the larger museum in our heads.

To think of Goya and Daumier as belonging together is normal. But it is a quite different thing, while looking at Daumier's *The Uprising*, to grasp a connection between its central figure, a worker in a white shirt shaking his upraised fist, and the white-shirted *Madrileno* defying the French muskets in Goya's *Third of May*.

None but a fool likes everything, and there were whole strands of modernism to which Duncan Phillips remained indifferent. He was not greatly moved by cubism, finding it—one might guess—too brown and cerebral. Nevertheless the collection boasts one of Juan Gris's finest works, a 1916 *Still Life with Newspaper*. He ignored most expressionism (too convulsive) and to Dada and surrealism he was quite indifferent, though he bought one Miró, *The Red Sun*, and accepted one great Schwitters as a gift from the estate of Katherine Dreier. Marcel Duchamp, the father of conceptual art and enemy of the "retinal," could safely be left to the Arensbergs in Philadelphia.

Phillips was in fact the compleat optical collector. He craved color sensation, the delight and radiance and sensory intelligence that is broadcast by an art based on color. Color healed; it consoled; it gave access to Eden. He could not understand—except on the plane of theory—why art should be expected to do anything else.

It had always been so for him, ever since childhood. When Duncan Phillips was four, his parents took him to Europe. In Paris, at the circus, he was terrified into hysterics by the sight of a clown tossing dolls—which the little American boy thought were live babies—into the air. His terror lasted all the way back to the

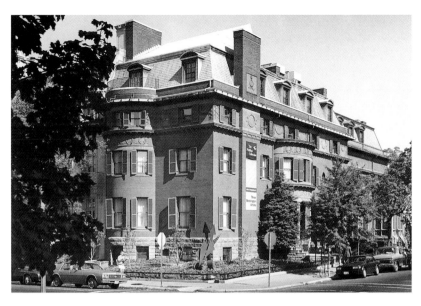

Exterior view of The Phillips Collection, *ca. 1980s.*

hotel and was only assuaged, Marjorie Phillips wrote in her memoir of her husband, by the sight of a vase of simple flowers in the lobby: blue cornflowers, red poppies, yellow buttercups. "He later remembered how he could not let the bouquet out of his sight and always thought that was his first real aesthetic experience of color." You might say that Phillips's lifetime attachment to color began with a therapeutic instant, one that could be recaptured over and over again, almost at will, in the presence of painting.

He came to see the significance of modern art largely as a narrative of color, of agreeable sense-impression laden with thought. He was not "a modernist," but he immersed himself in modernity as the living form of a tradition that, as he saw it, had begun in cinquecento Venice, among the mysterious reveries of Giorgione: an art of delicately managed emotion, rising from the intersection of culture and nature, in the pastoral mode. (The ideal opener for The Phillips Collection would have been Giorgione's *Tempesta*.)

He hated the laborious or sleeked image: Art needed to be fresh in its perception, direct in its touch. He wanted "works which add to my well-being.... For me, an artist's unique personality must transcend any imposed pattern which otherwise becomes an academic stencil adaptable to mass production." On Twenty-first Street today, his well-being is still ours.

MILTON AVERY

b. 1885, Sand Bank, New York. d. 1965, New York, New York

Girl Writing, 1941

Oil on canvas. 48 in.×32⅛ in. Acquired 1943

What was Avery's repertoire? His living room, Central Park, his wife Sally, his daughter March, the beaches and mountains where they summered; cows, fish heads, the flight of birds; his friends and whatever world strayed through his studio: a domestic, unheroic cast. But from these there have been fashioned great canvases, that far from the casual and transitory implications of the subjects, have always a gripping lyricism, and often achieve the permanence and monumentality of Egypt.

Mark Rothko, 1965

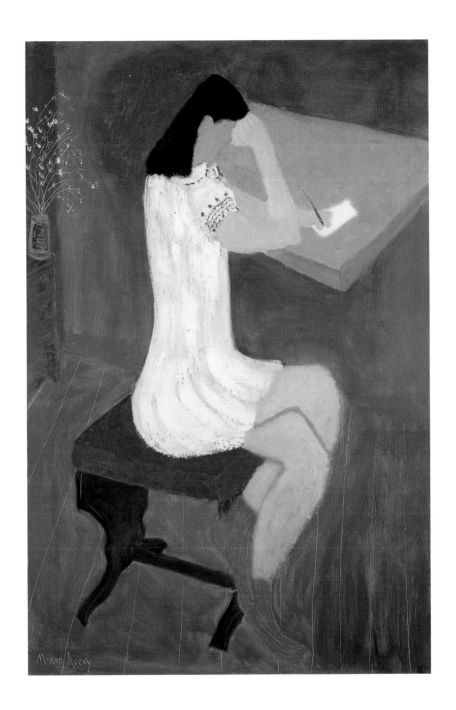

MILTON AVERY

b.1885, Sand Bank, New York. d.1965, New York, New York

Black Sea, 1959

Oil on canvas. 50¼ in.×68 in. Acquired 1965

I like to seize one sharp instant in nature, to imprison it by means of ordered shapes and space relationships. To this end I eliminate and simplify, leaving apparently nothing but color and pattern. I am not seeking pure abstraction; rather the purity and essence of the idea—expressed in its simplest form.

Milton Avery

FRANCIS BACON

b. 1909, Dublin, Ireland. d. 1992, Madrid, Spain

Study of a Figure in a Landscape, 1952

Oil on canvas. 78 in.×54¼ in. Acquired 1955

People always seem to think that in my paintings I'm trying to put across a feeling of suffering and the ferocity of life, but I don't think of it all in that way myself. You see, just the very fact of being born is a very ferocious thing, just existence itself as one goes between birth and death. It's not that I want to emphasize that side of things—but I suppose if you are trying to work as near to your nervous system as you can, that's what automatically comes out. . . . Life . . . is just filled, really, with suffering and despair.

Francis Bacon, 1980

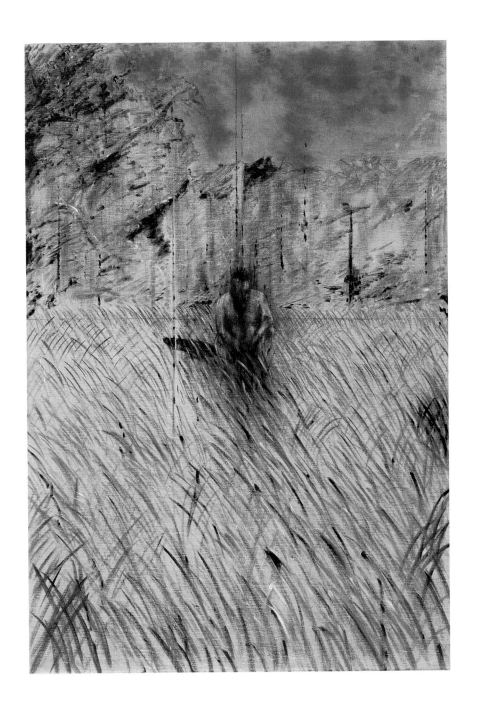

PIERRE BONNARD

b. 1867, Fontenay-aux-Roses, France. d. 1947, Le Cannet, France

The Open Window, 1921

Oil on canvas. 46½ in.×37¾ in. Acquired 1930

The important thing is to remember what most impressed you and to put it on canvas as fast as possible. Then, using only one color as a basis, you structure the entire painting around it. Color represents a logic that is just as unrelenting as the logic of form. One must never let go before having managed to set down one's first impressions.

Pierre Bonnard, 1937

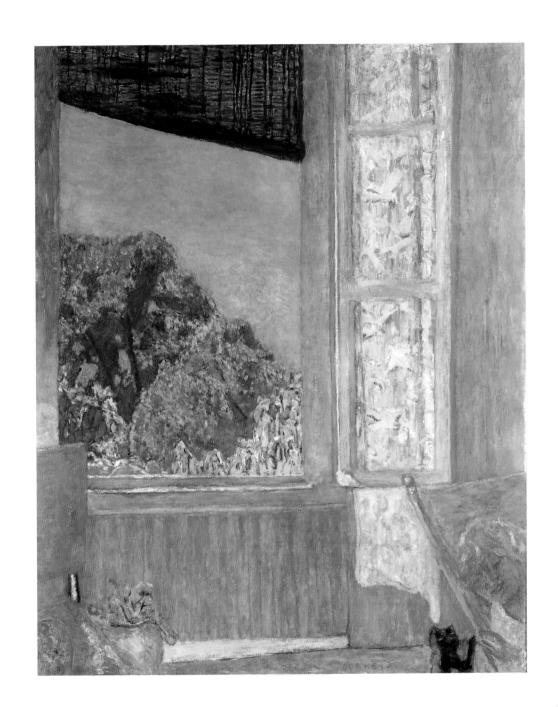

PIERRE BONNARD

b. 1867, Fontenay-aux-Roses, France. d. 1947, Le Cannet, France

The Palm, 1926

Oil on canvas. 45 in. × 57⅞ in. Acquired 1928

My work is going pretty well, especially in the direction of understanding. During my morning walks I amuse myself by defining different conceptions of landscape—landscape as "space," intimate landscape, decorative landscape, etc. But as for vision, I see things differently every day, the sky, objects, everything changes continually, you can drown in it. But that's what brings life.

Pierre Bonnard, 1940

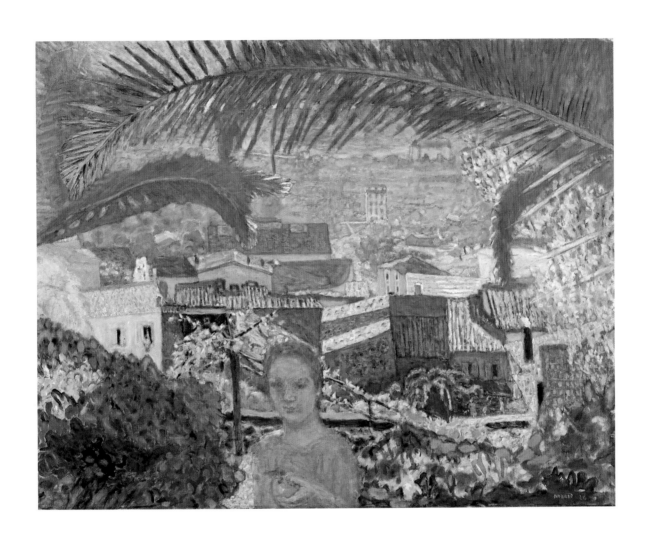

GEORGES BRAQUE

b. 1882, Argenteuil-sur-Seine, France. d. 1963, Paris, France

The Round Table, 1929

Oil on canvas. 57¼ in. × 44¾ in. Acquired 1934

Classical perspective had become something mechanically applied. It ended up making tactile reality more distant, instead of rendering it more visible. It imposed its dictatorial power on things, closed off the paths of independence, smothered them. . . . We, following Cézanne, have implanted a perspective that brings objects within reach of the hand and that describes them in relation to the artist himself. To bring things closer to the spectator's view, to encourage the communion of the tactile and the visible: I have so often explained this subject in relation to my work.

Georges Braque

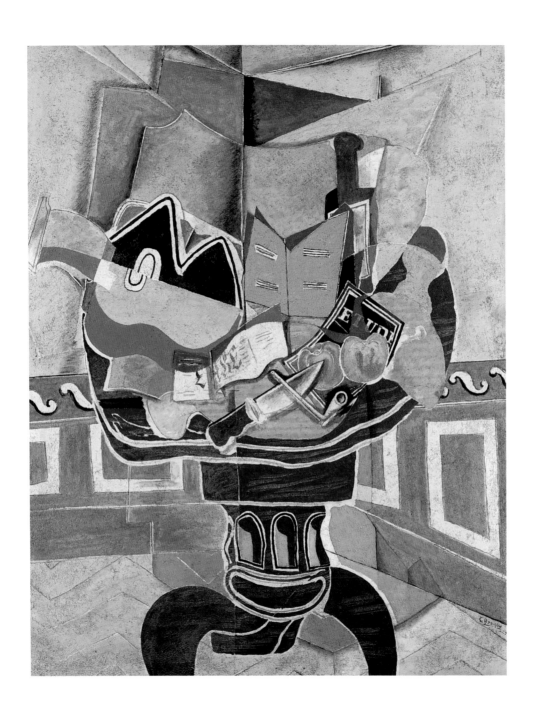

GEORGES BRAQUE

b. 1882, Argenteuil-sur-Seine, France. d. 1963, Paris, France

The Washstand, 1944

Oil on canvas. 63¾ in. × 25⅛ in. Acquired 1948

One begins to paint under the impulsion of an idea. Something happens first in one's head before it begins to happen in one's eyes. An idea takes shape. . . . But, as one goes on working, the picture itself takes over. That is to say, there is a tussle between the idea—the picture as it is conceived in advance—and the picture which fights for its own life. It is this conflict which creates that vital tension which gives life to a picture. Georges Braque, 1950

CHARLES BURCHFIELD

b.1893, Ashtabula Harbor, Ohio. d.1967, West Seneca, New York

Moonlight over the Arbor, 1916

Watercolor, gouache, and pencil on paper. 19¼ in.×13½ in. Acquired 1933

I know of few things so stirring as the poetry of distance. To look out over an illimitable space towards the horizon and behold the succession of overlapping trees, blackish green close at hand, fading by almost imperceptible degrees into the sky—life holds few greater beauties.

Charles Burchfield, 1914

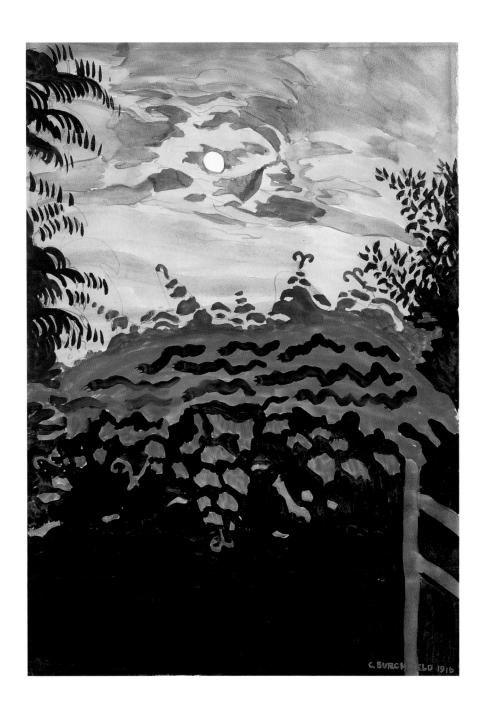

PAUL CÉZANNE

b. 1839, Aix-en-Provence, France. d. 1906, Aix-en-Provence, France

Self-Portrait, 1878–80

Oil on canvas. 23¾ in.×18½ in. Acquired 1928

It is almost touching to see him confirm how intense and incorruptible he could be in his observation by portraying himself with such objectivity, without remotely apologizing for his looks or condescending to them, with the good faith and concern for the simple facts exhibited by a dog who sees himself in the mirror and thinks: there's another dog.

Rainer Maria Rilke, 1907

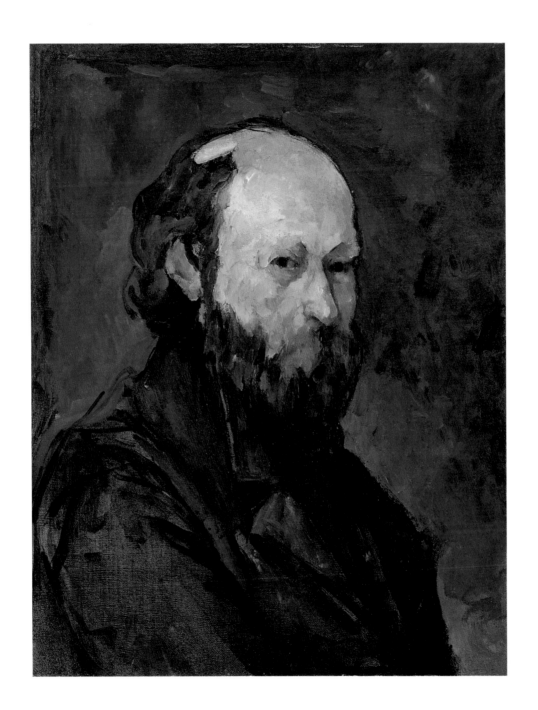

PAUL CÉZANNE

b. 1839, Aix-en-Provence, France. d. 1906, Aix-en-Provence, France

Mont Sainte-Victoire, 1886–87

Oil on canvas. 23½ in.×28½ in. Acquired 1925

Literature expresses itself by abstractions, whereas painting by means of drawing and color gives concrete shape to sensations and perceptions. One is neither too scrupulous nor too sincere nor too submissive to nature; but one is more or less master of one's model, and above all, of the means of expression. Get to the heart of what is before you and continue to express yourself as logically as possible.

Paul Cézanne, 1904

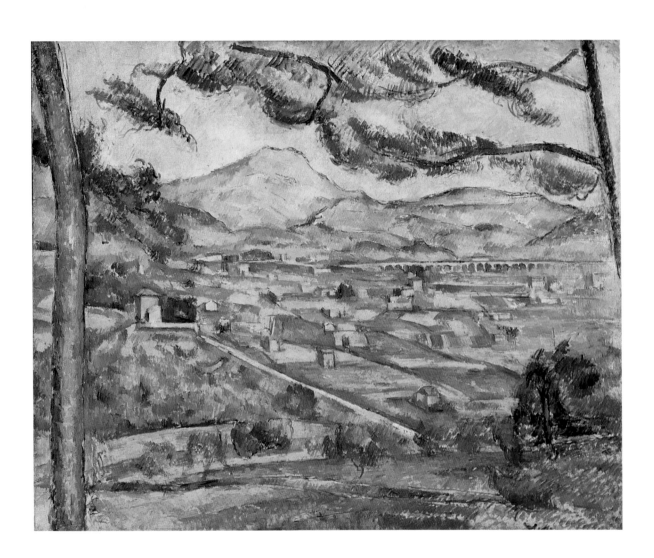

PAUL CÉZANNE

b.1839, Aix-en-Provence, France. d.1906, Aix-en-Provence, France

Le Jardin des Lauves, circa 1906

Oil on canvas. 25¾ in.×31⅞ in. Acquired 1955

Cézanne shows himself here completely the master of his new "water-colour" technique. Indeed the comparison with water-colour becomes here more justifiable, for he is able to leave large parts of the white canvas preparation intact. The touches of colour are often spaced out upon it. And yet if we view the canvas from the proper distance the effect of plastic continuity is complete. We recognize the relief and recession of each plane. The picture, with all the gaps in the colour, is completely finished. Cézanne has realized his early dream of a picture not only controlled but inspired by the necessities of the spirit, a picture which owes nothing to the data of any actual vision; but this he has achieved by a different route from that which first attracted him. It lies not by way of willed and *a priori* invention, but through the acceptance and final assimilation of appearance.

Roger Fry, 1927

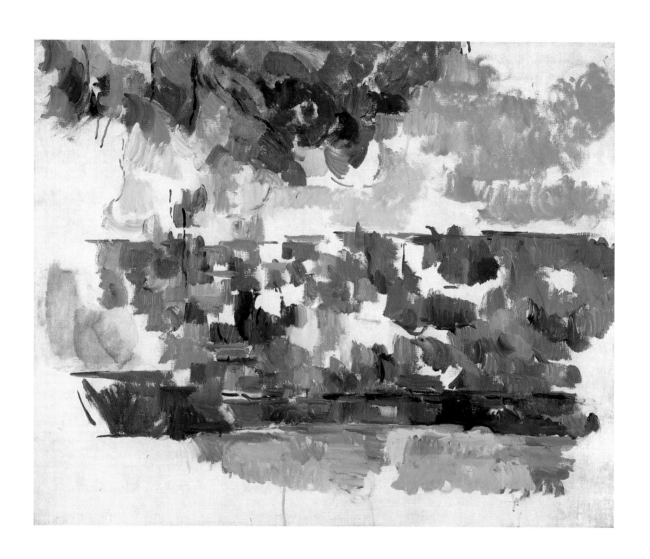

JEAN-BAPTISTE SIMÉON CHARDIN

b.1699, Paris, France. d.1779, Paris, France

A Bowl of Plums, circa 1728

Oil on canvas. 17¾ in.×22⅜ in. Acquired 1920

One can define the shape of every object in nature by showing the precise color tones of everything that surrounds it. . . . Nature is not to be rendered with the colors one buys from a merchant, but by accurately imitating its own *local* colors, its colors in relation to space and to the light that illuminates it.

Jean-Baptiste Siméon Chardin

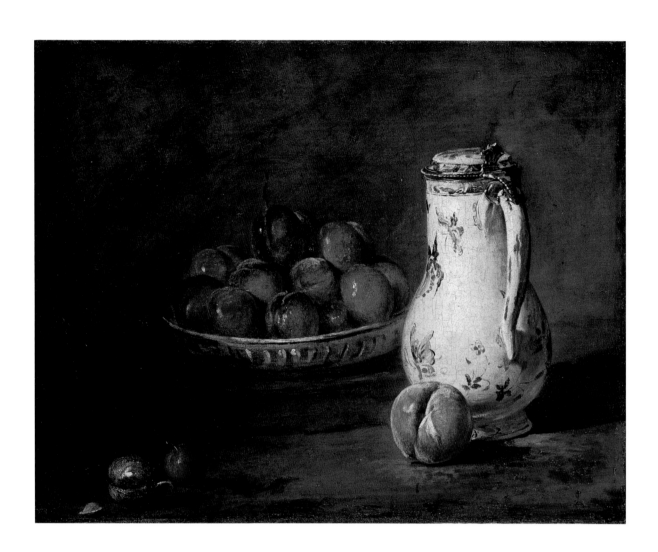

WILLIAM MERRITT CHASE

b. 1849, Williamsburg (now Nineveh), Indiana. d. 1916, New York, New York

Hide and Seek, 1888

Oil on canvas. 27⅝ in.×35⅞ in. Acquired 1923

It is never well to keep your work too much inside the frame. Carry it well out to the edge.

William Merritt Chase, 1896

Take only what you see at a glance without changing focus.

William Merritt Chase, 1913

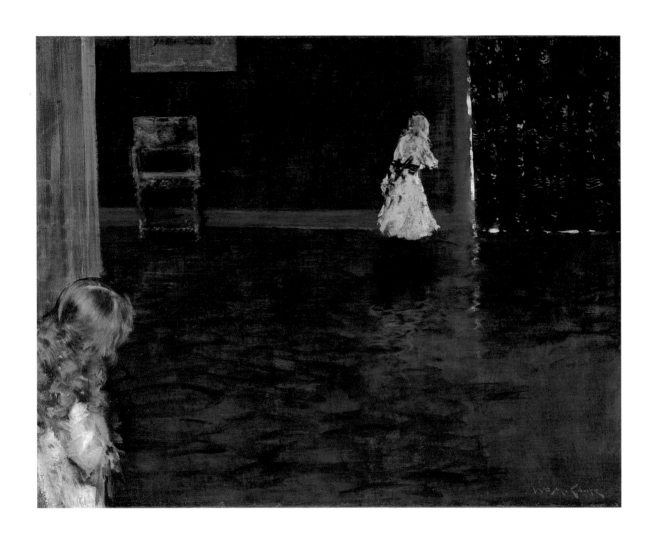

JEAN-BAPTISTE-CAMILLE COROT

b.1796, Paris, France. d.1875, Ville-d'Avray, France

View from the Farnese Gardens, Rome, 1826

Oil on paper mounted on canvas. 9¾ in.×15⅞ in. Acquired 1942

After my outing I invite Nature to come spend several days with me; that is when my madness begins. Brush in hand, I look for hazelnuts among the trees in my studio; I hear birds singing there, trees trembling in the wind; I see rushing streams and rivers laden with a thousand reflections of sky and earth; the sun sets and rises in my studio.

<div align="center">Jean-Baptiste-Camille Corot, 1853</div>

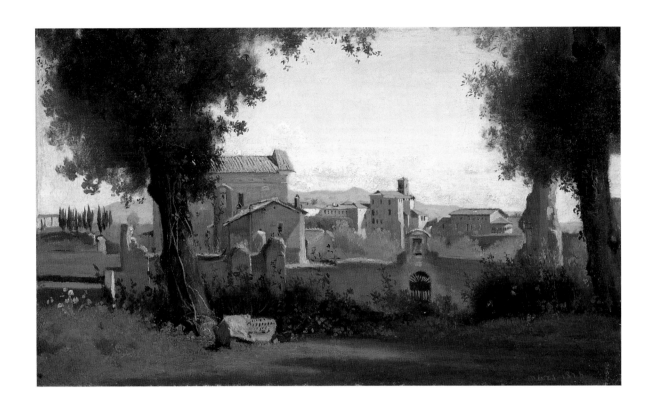

GUSTAVE COURBET

b. 1819, Ornans, Doubs, France. d. 1877, La Tour de Peilz, Switzerland

The Mediterranean, 1857

Oil on canvas. 23⅜ in. × 33½ in. Acquired 1924

The sea! The sea! Its charms sadden me, in its joy it makes me think of a laughing tiger, in its sadness it reminds me of the tears of a crocodile; in its fury it is a roaring monster in a cage which cannot swallow me.

Gustave Courbet, 1864

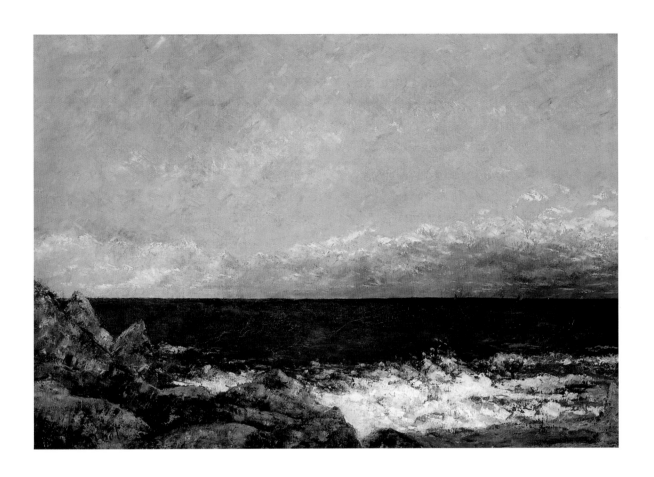

HONORÉ DAUMIER

b.1808, Marseilles, France. d.1879, Valmondois, France

The Uprising, circa 1848

Oil on canvas. 34½ in.×44½ in. Acquired 1925

Of course Daumiers only occur once in a thousand years. But he should be the inspiration to the artists of our democracy. His masterpiece depicts the volcanic explosion of all enslaved people everywhere. The Paris of its background might be the tragic Europe of today. The magnetic agitator of its focus is the rallying point for the Uprisings of tomorrow, pent up and ready to burst.

Duncan Phillips, 1942

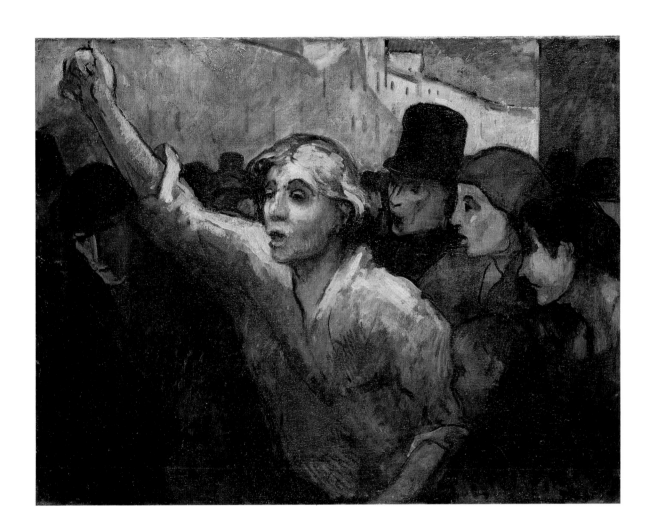

HONORÉ DAUMIER

b.1808, Marseilles, France. d.1879, Valmondois, France

The Painter at His Easel, circa 1870

Oil on wood panel. 13⅛ in.×10⅛ in. Gift of Marjorie Phillips, 1944

As artist, Daumier's distinguished mark is sureness of hand. He draws like the old masters. His drawing is rich and flowing, it is an uninterrupted improvisation and yet it is not just chic. He has a wonderful and almost divine visual memory, which takes the place of the model. All his figures stand firmly and are faithfully portrayed in movement. His gift of observation is so sure that it would be impossible to find in his drawings a single head that does not seem to fit on to the body that carries it. A given nose, a given forehead, an eye, foot, hand; it is all the logic of the scholar transplanted into a light and fleeting art, which competes with the mobility of life itself.

Charles Baudelaire, 1857

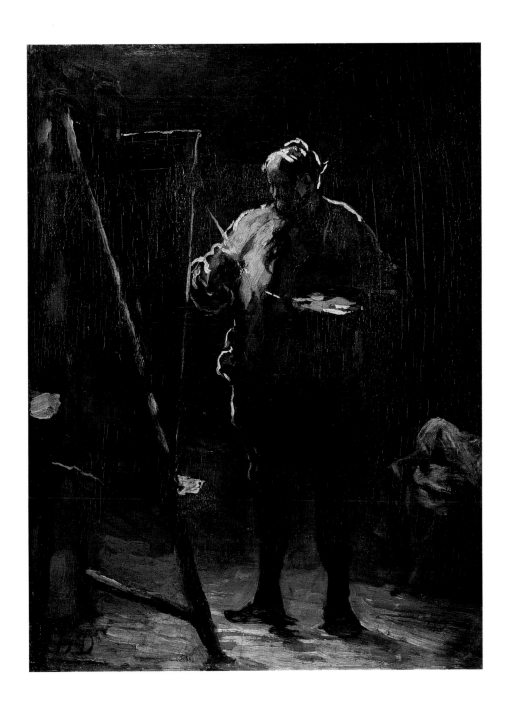

STUART DAVIS

b. 1892, Philadelphia, Pennsylvania. d. 1964, New York, New York

Egg Beater No. 4, 1927

Oil on canvas. 27 in.×38¼ in. Acquired 1939

My purpose is to make Realistic pictures. I insist upon this definition in spite of the fact that the type of work I am now doing is generally spoken of as Abstraction. The distinction is important in that it may lead people to realize that they are to look at what is there instead of hunting for symbolic suggestions. A picture is always a three-dimensional illusion regardless of subject matter.

Stuart Davis, 1927

STUART DAVIS

b. 1892, Philadelphia, Pennsylvania. d. 1964, New York, New York

Blue Café, 1928

Oil on canvas. 18⅛ in. × 21⅝ in. Acquired 1930

Every time you use a color, you create a space relationship. It is impossible to put two colors together, even at random, without setting up a number of other events.

<div align="right">Stuart Davis, 1957</div>

HILAIRE-GERMAIN-EDGAR DEGAS

b. 1834, Paris, France. d. 1917, Paris, France

Melancholy, late 1860s

Oil on canvas. 7½ in. × 9¾ in. Acquired 1941

Yesterday I spent my afternoon in the atelier of a strange painter named Degas. After many attempts, experiments, and thrusts in every direction, he has fallen in love with modern subjects and has set his heart on laundry girls and danseuses. I cannot find his choice bad.... This Degas is an original fellow, sickly, neurotic, and afflicted with eye trouble to the point of being afraid of going blind, but for those very reasons he is an excessively sensitive person who reacts strongly to the true character of things. Of all the men I have seen engaged in depicting modern life, he is the one who has most successfully rendered the inner nature of that life. One wonders, however, whether he will ever produce something really complete. I doubt it. He seems to have a very restless mind.

Edmond de Goncourt, 1877

HILAIRE-GERMAIN-EDGAR DEGAS

b. 1834, Paris, France. d. 1917, Paris, France

After the Bath, circa 1895

Pastel on paper. 30 in.×32⅞ in. Acquired 1949

Hitherto the nude has always been represented in poses which presuppose an audience, but these women of mine are honest, simple folk, unconcerned by any other interests than those involved in their physical condition. . . . It is as if you looked through a keyhole.

<div align="center">Hilaire-Germain-Edgar Degas, before 1891</div>

HILAIRE-GERMAIN-EDGAR DEGAS

b.1834, Paris, France. d.1917, Paris, France

Dancers at the Barre, circa 1900

Oil on canvas. 51¼ in.×38½ in. Acquired 1944

In its monumentality it is unique among all his decorations celebrating the arabesques and occupational anatomy of ballet dancers. This masterpiece of color contrast and harmony is also a daring record of instantaneous change at a split second of observation. Degas miraculously avoided the danger to art of arrested motion and actually transformed the incident of swiftly seen shapes in time into a thrilling vision of dynamic forms in space. As a draftsman Degas is one of the greatest masters of line as an instrument of expressive revelation. In this example of his experimentalism he elongated the figures arbitrarily with a virtuosity which rose above mannerism, and he sustained this daring with a tangerine orange wall which did not advance beyond the cool flesh tones and pale blue ballet skirt.

Duncan Phillips, 1956

WILLEM DE KOONING

b. 1904, Rotterdam, The Netherlands. d. 1997, East Hampton, New York

Asheville, 1949

Oil on illustration board. 25½ in.×32 in. Acquired 1952

Of all movements, I like Cubism most. It had that wonderful unsure atmo-
sphere of reflection—a poetic frame where something could be possible, where
an artist could practice his intuition. It didn't want to get rid of what went be-
fore. Instead it added something to it. The parts that I can appreciate in other
movements came out of Cubism.

Willem de Kooning, 1951

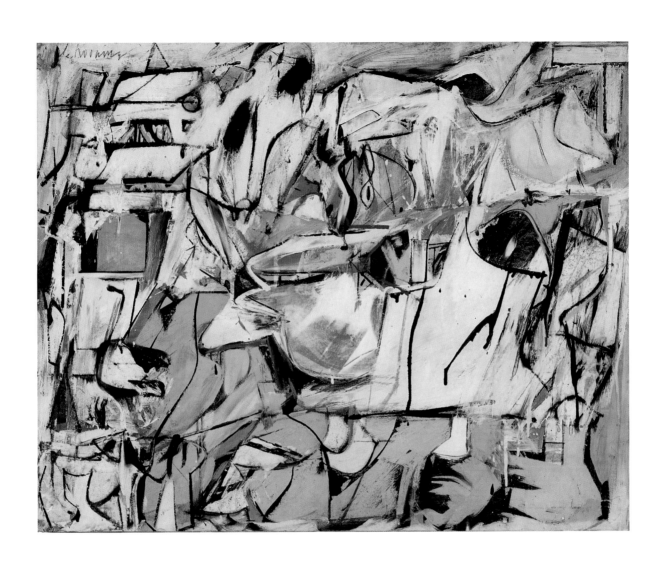

FERDINAND-VICTOR-EUGÈNE DELACROIX

b.1798, Charenton-St. Maurice, France. d.1863, Paris, France

Paganini, circa 1832

Oil on cardboard on wood panel. 17⅝ in.×11⅞ in. Acquired 1922

The original idea, the sketch, which is so to speak the egg or embryo of the idea, is usually far from being complete; it contains everything, which is simply a mixing together of all parts. Just the thing that makes of this sketch the essential expression of the idea is not the suppression of the details, but their complete subordination to the big lines which are, before all else, to create the impression. The greatest difficulty therefore is that of returning in the picture to that effacing of the details which, however, make up the composition, the web and the woof of the picture. Ferdinand-Victor-Eugène Delacroix, 1854

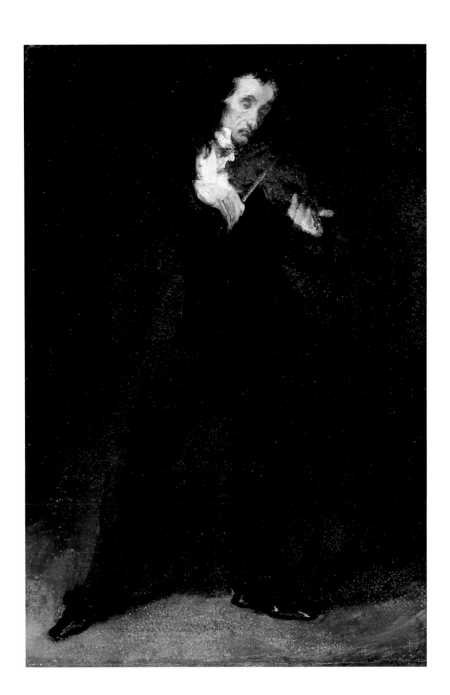

RICHARD DIEBENKORN

b.1922, Portland, Oregon. d.1993, Berkeley, California

Girl with Plant, 1960

Oil on canvas. 80 in.×70 in. Acquired 1961

As soon as I started using the figure my whole idea of my painting changed. Maybe not in the most obvious structural sense, but these figures distorted my sense of interior or environment, or the painting itself—in a way that I welcomed. Because you don't have this in abstract painting. . . . In abstract painting one can't deal with . . . an object or person, a concentration of psychology which a person is as opposed to where the figure *isn't* in the painting. . . . And that's the one thing that's always missing for me in abstract painting, that I don't have this kind of dialogue between elements that can be . . . wildly different and can be at war, or in extreme conflict.

Richard Diebenkorn, circa 1985

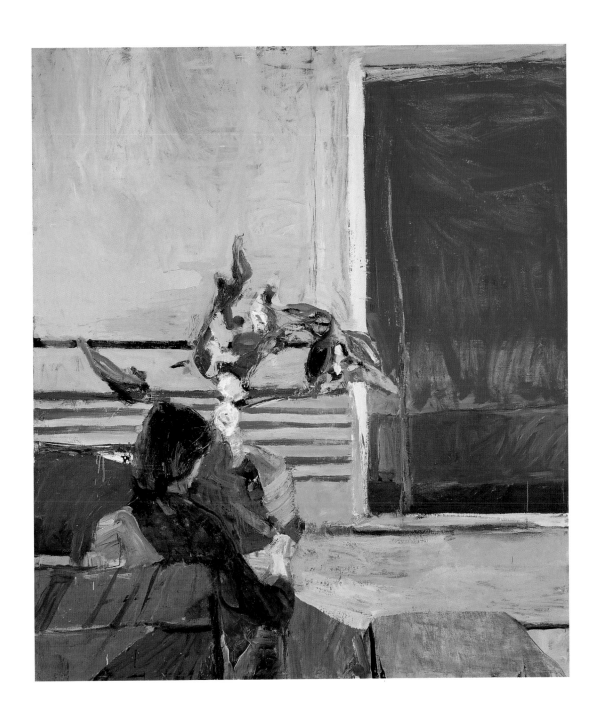

ARTHUR DOVE

b. 1880, Canandaigua, New York. d. 1946, Huntington, New York

Goin' Fishin', 1925

Collage on wood panel. 19½ in.×24 in. Acquired 1937

Perhaps art is just taking out what you don't like and putting in what you do. There is no such thing as abstraction. It is extraction, gravitation toward a certain direction, and minding your own business. If the extract be clear enough its value will exist. It is nearer to music, not the music of ears, just the music of the eyes. It should necessitate no effort to understand. Just to look, and, if looking gives vision, enjoyment should occur as the eyes look.

Arthur Dove, 1929

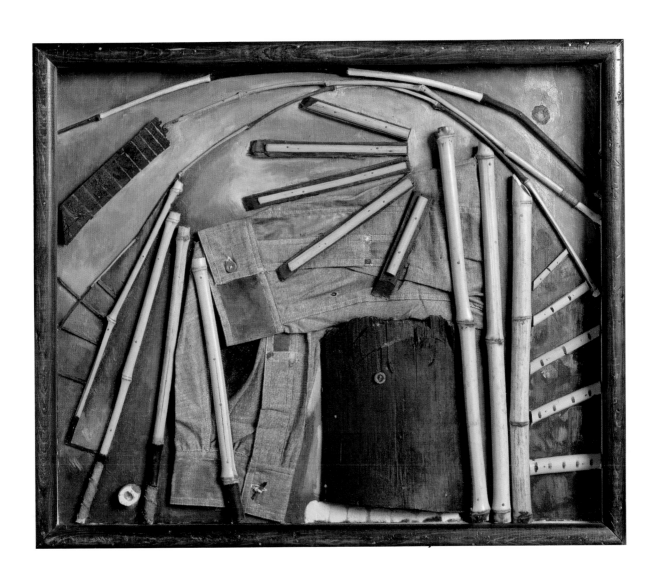

ARTHUR DOVE

b.1880, Canandaigua, New York. d.1946, Huntington, New York

Me and the Moon, 1937

Wax emulsion on canvas. 18 in.×26 in. Acquired 1939

We have not yet made shoes that fit like sand
Nor clothes that fit like water
Nor thoughts that fit like air,
There is much to be done—
Works of nature are abstract,
They do not lean on other things for meaning.

Arthur Dove, 1925

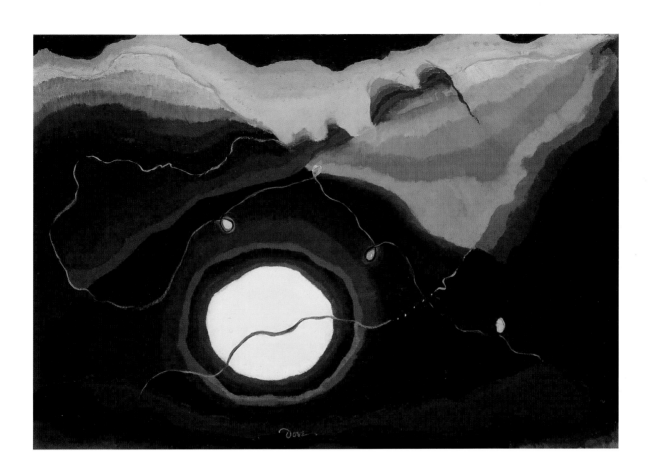

THOMAS EAKINS

b. 1844, Philadelphia, Pennsylvania. d. 1916, Philadelphia, Pennsylvania

Miss Amelia Van Buren, circa 1891

Oil on canvas. 45 in.×32 in. Acquired 1927

The big artist does not sit down monkey-like and copy, . . . but he keeps a sharp eye on Nature and steals her tools. He learns what she does with light, the big tool, and then color, then form, and appropriates them to his own use. . . . But if he ever thinks he can sail another fashion from Nature or make a better-shaped boat, he'll capsize.

Thomas Eakins, circa 1866–68

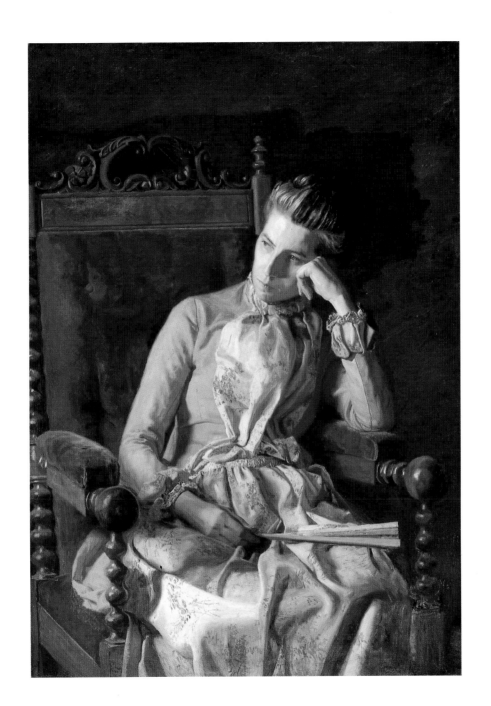

SAM FRANCIS

b. 1923, San Mateo, California. d. 1994, Santa Monica, California

Blue, 1958

Oil on canvas. 48 in.×34¾ in. Acquired 1958

What we want is to make something that fills utterly the sight and can't be used to make life only bearable; if the painting till now was a way of making bearable the sight of the unbearable, the visible sumptuous, then let's now strip away . . . all that.

These paintings lie under the cloud that soared over the inlaid sea.

Do you still lie dreaming under that huge canvas? Complete vision abandons the three-times-divided soul and its vapours; it is the cloud come over the inlaid sea. You can't interpret the dream of the canvas for this dream is at the end of the hunt on the heavenly mountain—where nothing remains but the phoenix caught in the midst of lovely blueness.

Sam Francis, 1957

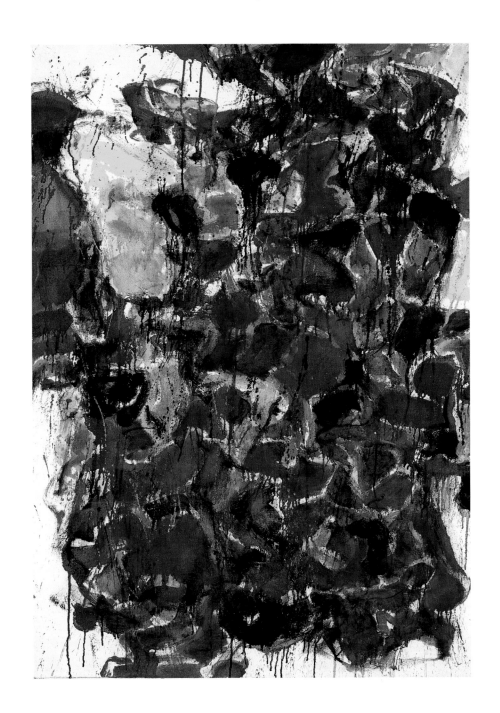

LEE GATCH

b. 1902, near Baltimore, Maryland. d. 1968, Lambertville, New Jersey

Industrial Night, 1948

Oil on canvas. 17 ¾ in. × 39 ¾ in. Acquired 1949

My hopes for the future are to seek ever through reality for a finer mystical expression and a greater economy of means in reaching the essence of the idea.

Lee Gatch, 1949

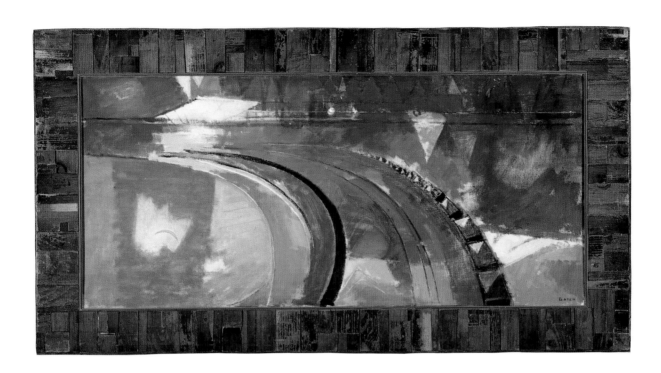

PAUL GAUGUIN

b. 1848, Paris, France. d. 1903, Tahiti

Still Life with Ham, 1889

Oil on canvas. 19¾ in. × 22¾ in. Acquired 1951

One bit of advice, don't copy nature too much. Art is an abstraction; derive this abstraction from nature while dreaming before it, but think more of creating than of the actual result. The only way to rise towards God is by doing as our divine Master does, create.

Paul Gauguin, 1888

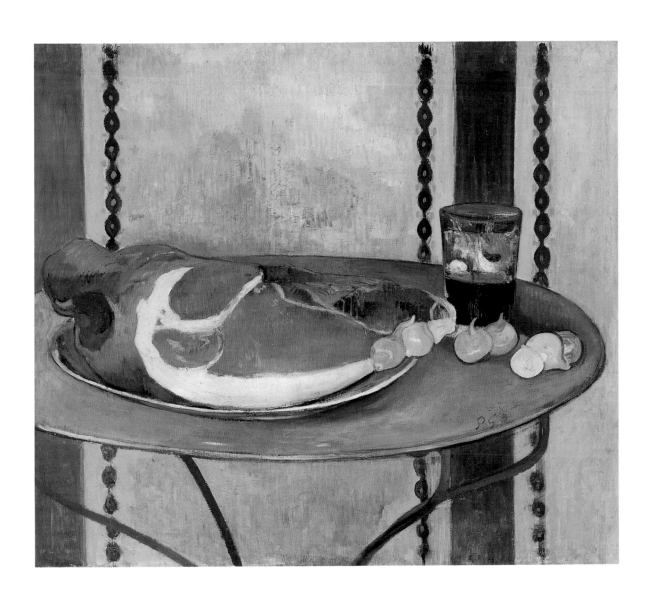

WILLIAM GLACKENS

b.1870, Philadelphia, Pennsylvania. d.1938, Westport, Connecticut

Bathers at Bellport, circa 1912

Oil on canvas. 24⅞ in.×29⅞ in. Acquired 1929

In Paris, after a day's painting, a long day's painting, he would frequently go for an aperitif, a French vermouth usually, to the Café du Dôme. He would then sometimes make comments on the day's work. They would generally be in something of this vein: "How do you paint a hand?" or "When do you know that your picture looks like the sitter—how can you tell?" And then the subject would be, suddenly, changed. The man has no affectations whatever and no consciousness, apparently, of his accomplishment. And though he must, as every painter does, rely a great deal upon past experience and performance, he gives you no inkling of its counting with him at all. This picture is better than that one but—wait. "How do you paint a hand?"

Guy Pène du Bois, 1931

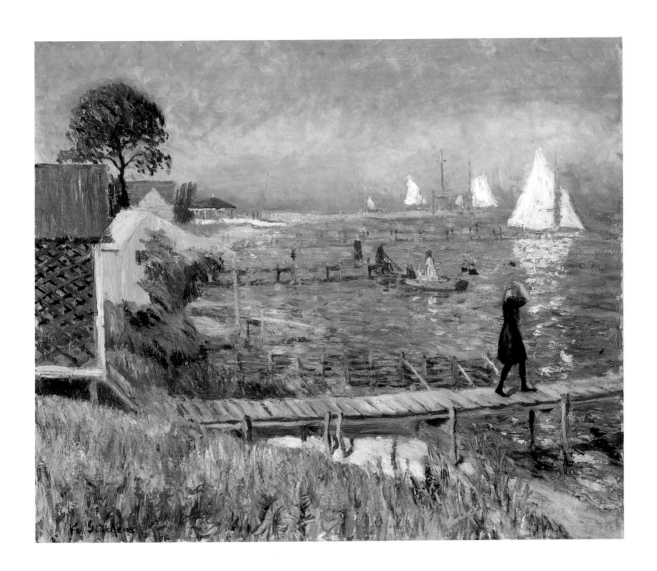

VINCENT VAN GOGH

b.1853, Groot-Zundert, The Netherlands. d.1890, Auvers-sur-Oise, France

Entrance to the Public Gardens in Arles, 1888

Oil on canvas. 28½ in.×35¾ in. Acquired 1930

So I am always between two currents of thought, first the material difficulties, turning round and round and round to make a living; and second, the study of color. I am always in hope of making a discovery there, to express the love of two lovers by a marriage of two complementary colors, their mingling and their opposition, the mysterious vibrations of kindred tones. To express the thought of a brow by the radiance of a light tone against a somber background.

Vincent van Gogh, 1888

I want to paint men and women with that something of the eternal which the halo used to symbolize, and which we seek to convey by the actual radiance and vibration of our colouring.

Vincent van Gogh, 1888

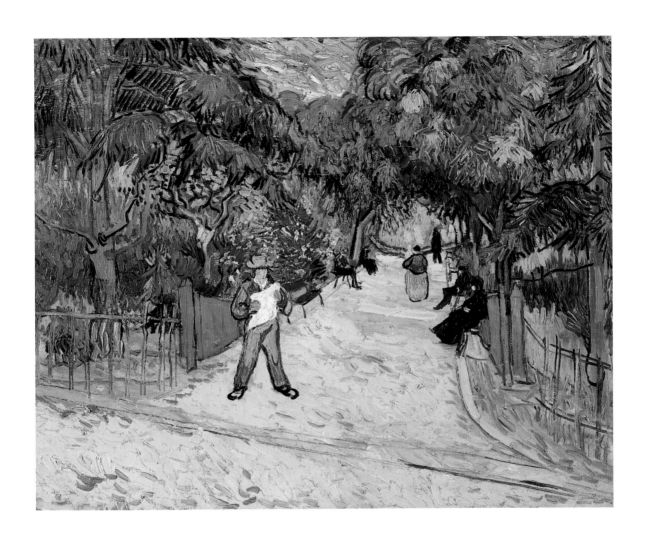

VINCENT VAN GOGH

b.1853, Groot-Zundert, The Netherlands. d.1890, Auvers-sur-Oise, France

The Road Menders, 1889

Oil on canvas. 29 in.×36½ in. Acquired 1949

The last study I have done is a view of the village, where they were at work—
under some enormous plane trees—repairing the pavements. So there are heaps
of sand, stones and the gigantic trunks—the leaves yellowing and here and there
you get a glimpse of a housefront and small figures.

<div align="right">Vincent van Gogh, 1889</div>

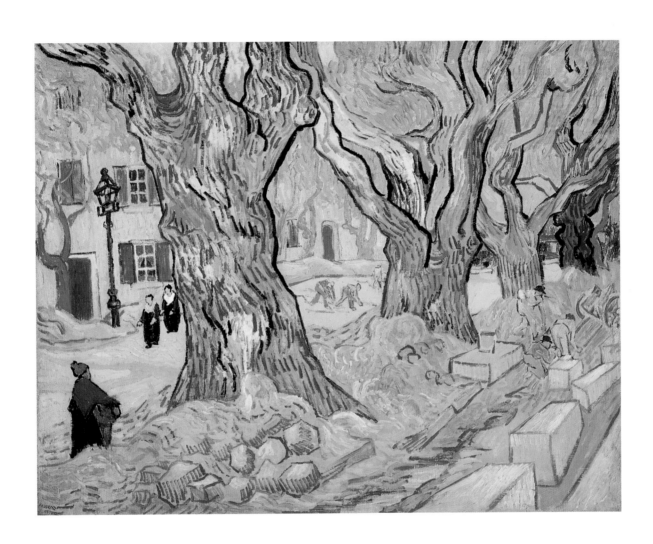

ADOLPH GOTTLIEB

b. 1903, New York, New York. d. 1974, East Hampton, New York

The Seer, 1950

Oil on canvas. 59¾ in. × 71⅝ in. Acquired 1952

I disinterred some relics from the secret crypt of Melpomene to unite them through the pictograph, which has its own internal logic. Like those early painters, who placed their images on the grounds of rectangular compartments, I juxtaposed my pictographic images, each self-contained within the painter's rectangle, to be ultimately fused within the mind of the beholder.

Adolph Gottlieb, 1944

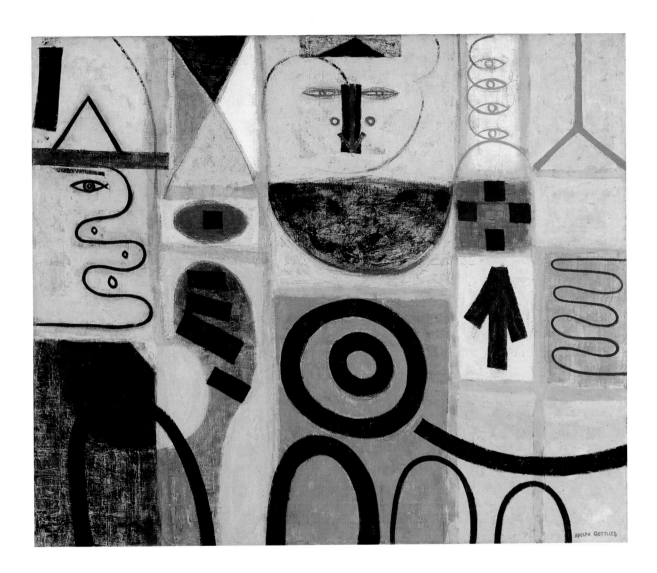

FRANCISCO JOSÉ DE GOYA Y LUCIENTES

b.1746, Fuendetodos, Spain. d.1828, Bordeaux, France

The Repentant St. Peter, circa 1820–24

Oil on canvas. 28⅞ in.×25½ in. Acquired 1936

This late Goya depicting the remorse of Peter anticipates Cézanne's modeling by modulations, also his weight and grandeur. This is not a spirit in flame like El Greco's expressionist version of the same theme, which is also in The Phillips Collection. Goya's Peter is a rock—the universal building block. In this master-piece of his last years the ever resourceful Goya had become more inventive for his more urgently expressive need. Within the pyramidal form the inner triangles stress the inner tension no less than the geometrical structure.

Duncan Phillips, 1956

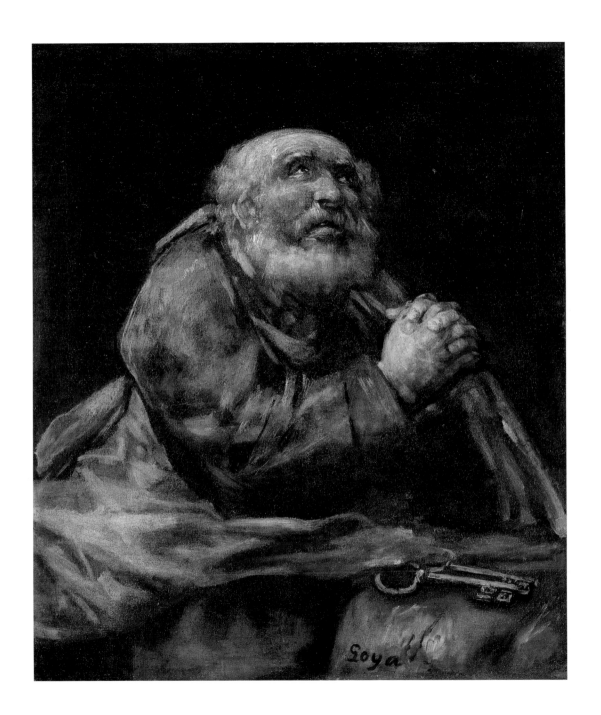

MORRIS GRAVES

b. 1910, Fox Valley, Oregon

Surf and Bird, circa 1940

Gouache on paper. 26½ in.×29¾ in. Acquired 1942

I paint to evolve a changing language of symbols, a language with which to re-mark upon the qualities of our mysterious capacities which direct us toward ul-timate reality. I paint to rest from the phenomena of the external world—to pronounce it—and to make notations of its essences with which to verify the inner eye.

Morris Graves, 1942

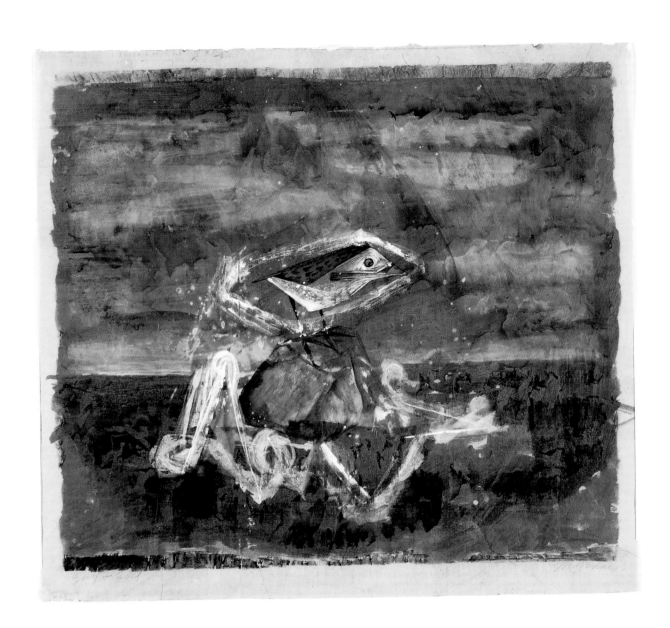

EL GRECO
(DOMÉNIKOS THEOTOKÓPOULOS)

b.1541, Candia, Crete. d.1614, Toledo, Spain

The Repentant St. Peter, circa 1600–1605 or later

Oil on canvas. 36⅞ in.×29⅞ in. Acquired 1923

Spiritual visions gave scope and meaning to his technical exploits. At last he could identify his passion for religion with his passion for dynamic emotional expression by plastic means. All nature was to El Greco as a living presence. Because of the intensity of his desire to express his sense of universal movement and aspiration, he resorted to forms projected arbitrarily in light and willfully distorted in anguish and rapture. The incandescent color, ascending in spirals of silver flames, suggests the yearning of souls under fierce repression.

Duncan Phillips, 1926

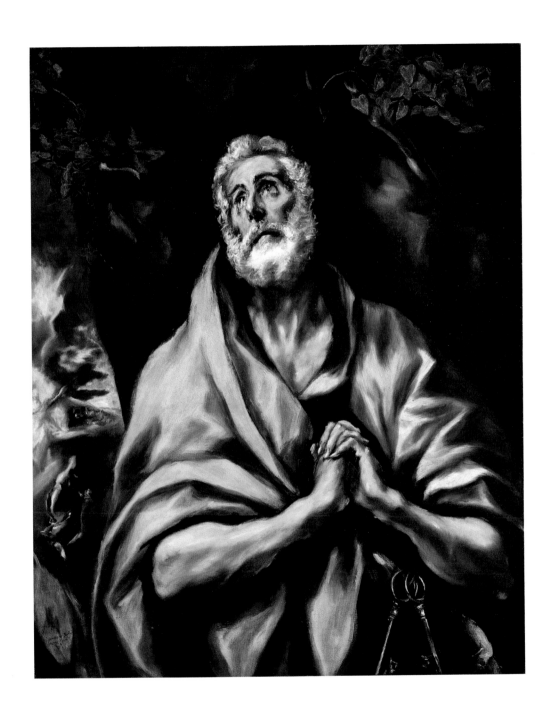

JUAN GRIS

b.1887, Madrid, Spain. d.1927, Boulogne-sur-Seine, France

Still Life with Newspaper, 1916

Oil on canvas. 29 in.×23¾ in. Acquired 1950

At all events I find my pictures excessively cold. But Ingres is cold too, and yet it is good, and so is Seurat; yes, so is Seurat whose meticulousness annoys me almost as much as my own pictures.

Juan Gris, 1915

I work with the elements of the intellect, with the imagination. I try to make concrete that which is abstract. I proceed from the general to the particular, by which I mean that I start with an abstraction in order to arrive at a true fact.

Juan Gris, 1921

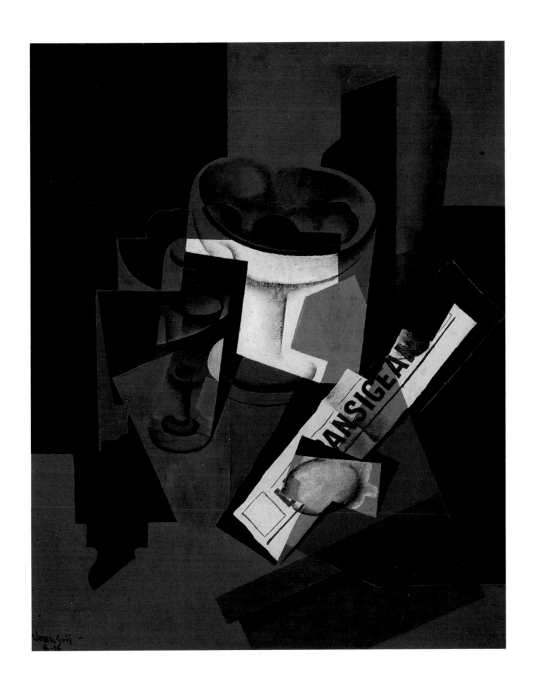

PHILIP GUSTON

b. 1913, Montreal, Canada. d. 1980, Woodstock, New York

Native's Return, 1957

Oil on canvas. 64⅞ in.×75⅞ in. Acquired 1958

The sense of unease we feel when we look at a Guston painting is that we have no idea that we must now make a leap into this Abstract emotion; we look for the painting in what we think is its reality—on the canvas. Yet the penetrating thought, the unbearable creative pressure inherent in the Abstract Experience reveals itself constantly as a *unified emotion*.

Morton Feldman, 1971

MARSDEN HARTLEY

b.1877, Lewiston, Maine. d.1943, Ellsworth, Maine

Off the Banks at Night, 1942

Oil on masonite. 30 in.×40 in. Acquired 1943

My paintings are the product of wild wander and madness for roaming—little visions of the great intangible.

Marsden Hartley, 1908

There is something beyond the intellect which intellect cannot explain—There are sensations in the human consciousness beyond reason—and painters are learning to trust these sensations and make them authentic on canvas. This is what I am working for.

Marsden Hartley, 1913

CHILDE HASSAM

b. 1859, Dorchester, Massachusetts. d. 1935, East Hampton, New York

Washington Arch, Spring, 1890

Oil on canvas. 27⅛ in.×22½ in. Acquired 1921

As the artist practices his peaceful profession, he can hold himself aloof from the rabble without the least danger or damage to his work. He is alone. If this is happiness, he has it, as his part in an invisible world, if anyone has it. He has what the saints sought for in the desert.

Childe Hassam

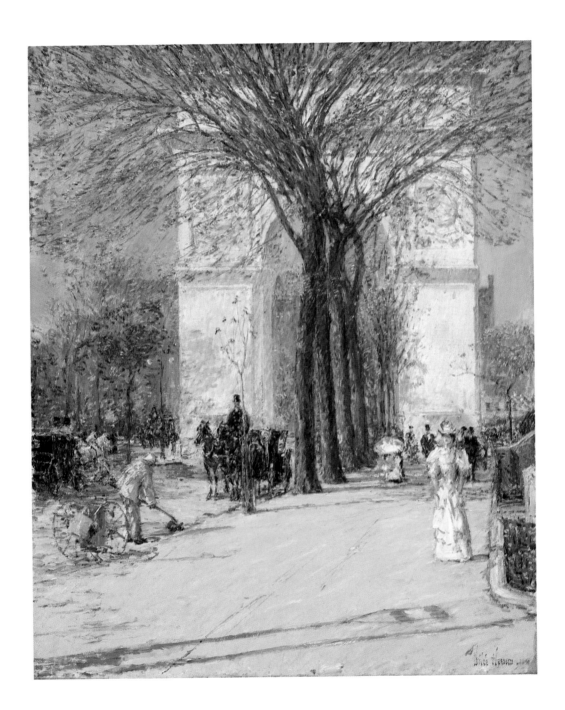

WINSLOW HOMER

b. 1836, Boston, Massachusetts. d. 1910, Prouts Neck, Maine

To the Rescue, 1886

Oil on canvas. 24 in.×30 in. Acquired 1926

I prefer every time . . . a picture composed and painted out-doors. The thing is done without your knowing it. . . . This making studies and then taking them home to use is only half right. You get composition, but you lose freshness, you miss the subtle and, to the artists, the finer characteristics of the scene itself.

Winslow Homer

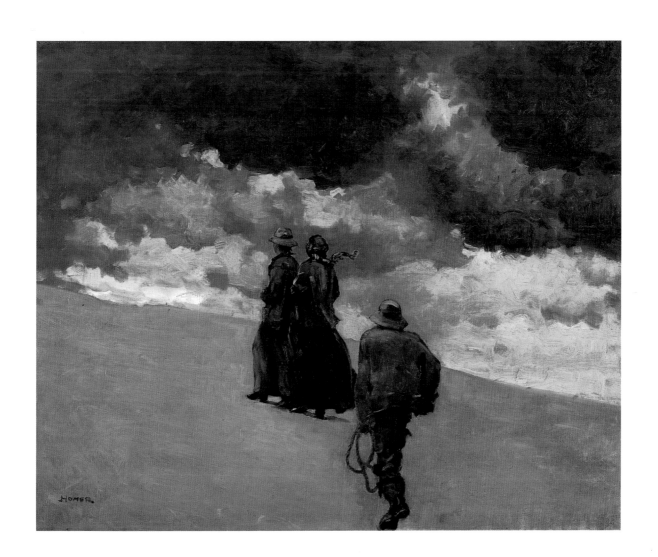

EDWARD HOPPER

b.1882, Nyack, New York. d.1967, New York, New York

Sunday, 1926

Oil on canvas. 29 in.×34 in. Acquired 1926

It's probably a reflection of my own, if I may say, loneliness. I don't know. It could be the whole human condition.

Edward Hopper, 1964

My aim in painting is always, using nature as the medium, to try to project upon canvas my most intimate reaction to the subject as it appears when I like it most; when the facts are given unity by my interest and prejudices. Why I select certain subjects rather than others, I do not exactly know, unless it is that I believe them to be the best mediums for a synthesis of my inner experience.

Edward Hopper, 1939

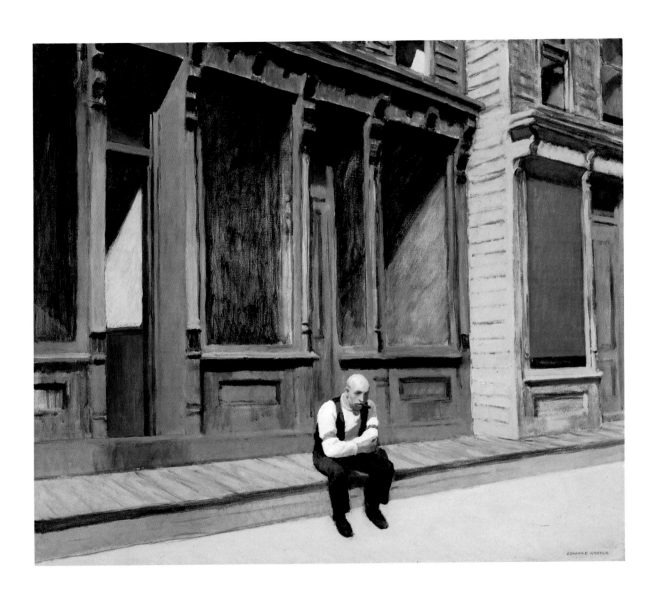

EDWARD HOPPER

b.1882, Nyack, New York. d.1967, New York, New York

Approaching a City, 1946

Oil on canvas. 27⅛ in.×36 in. Acquired 1947

I've always been interested in approaching a big city by train, and I can't exactly describe the sensations. But they're entirely human and perhaps have nothing to do with esthetics. There is a certain fear and anxiety, and a great visual interest in things that one sees coming into the city.

Edward Hopper, 1960

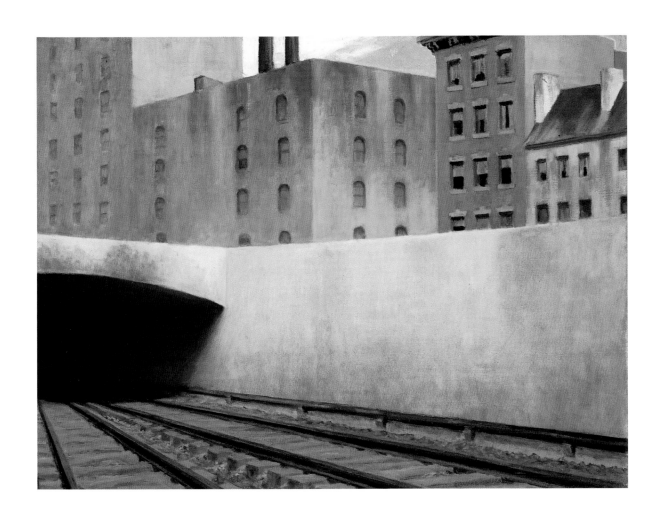

JEAN-AUGUSTE-DOMINIQUE INGRES

b.1780, Montauban, France. d.1867, Paris, France

The Small Bather, 1826

Oil on canvas. 12⅞ in.×9⅞ in. Acquired 1948

When one knows one's craft well, when one has learned well how to imitate nature, the chief consideration for a good painter is to think out the whole of his picture, to have it in his head as a whole, so to speak, so that he may then execute it with warmth and as if the entire thing were done at the same time. Then, I believe, everything seems to be felt together. Therein lies the characteristic quality of the great master, and there is the thing that one must acquire by dint of reflecting day and night on one's own art.

Jean-Auguste-Dominique Ingres, 1813

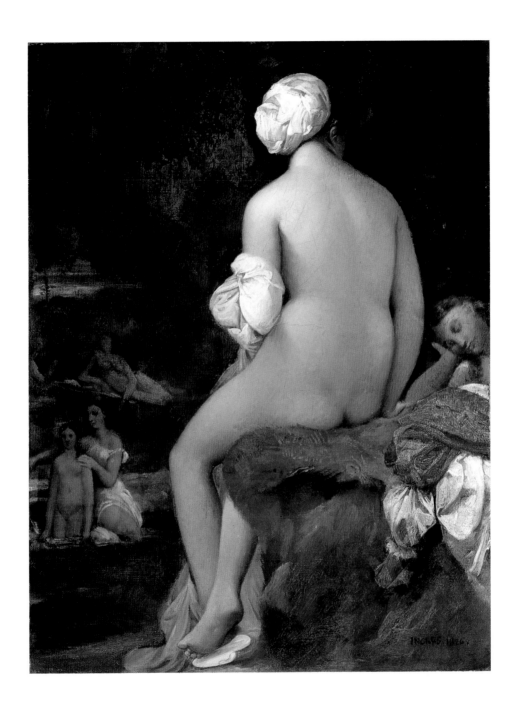

GEORGE INNESS

b.1825, Newburgh, New York. d.1894, Bridge-of-Allan, Scotland

Lake Albano, 1869

Oil on canvas. 30⅜ in.×45⅜ in. Acquired 1920

The highest art is where has been most perfectly breathed the sentiment of humanity. Rivers, streams, the rippling brook, the hill-side, the sky, clouds—all things that we see—can convey that sentiment if we are in the love of God and the desire of truth. Some persons suppose that landscape has no power of communicating human sentiment. But this is a great mistake. The civilized landscape particularly can; and therefore I love it more and think it more worthy of reproduction than that which is savage and untamed. It is more significant. Every act of man, every thing of labor, effort, suffering, want, anxiety, necessity, love, marks itself wherever it has been. In Italy I remember frequently noticing the peculiar ideas that came to me from seeing odd-looking trees that had been used, or tortured, or twisted—all telling something about humanity. American landscape, perhaps, is not so significant; but still every thing in nature has something to say to us. No artist need fear that his work will not find sympathy if only he works earnestly and lovingly.

George Inness, 1878

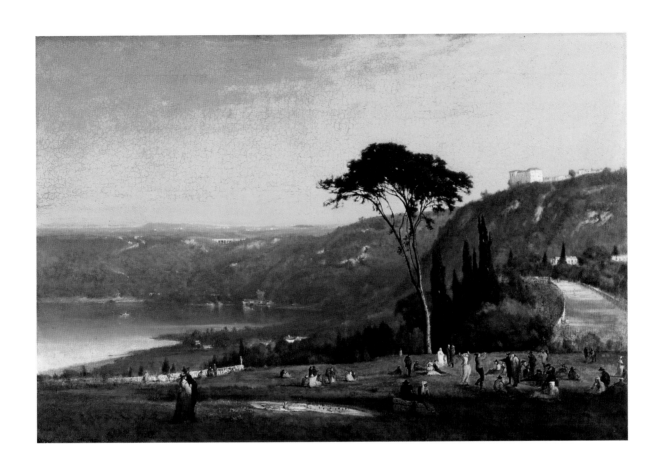

WASSILY KANDINSKY

b. 1866, Moscow, Russia. d. 1944, Neuilly-sur-Seine, France

Autumn II, 1912

Oil and washes on canvas. 24 in. × 32½ in. Acquired 1945

I have to look into the depths of my own being to judge how colors affect my soul. . . . I've made quite significant inroads into the subject and can see my way ahead pretty clearly. I think I can say without exaggerating that if I accomplish this project, I shall be pointing the way to a beautiful, new method of painting with infinite possibilities for development. I am breaking new ground only dreamed of periodically by some masters. Sooner or later people will recognize it.

Wassily Kandinsky, 1904

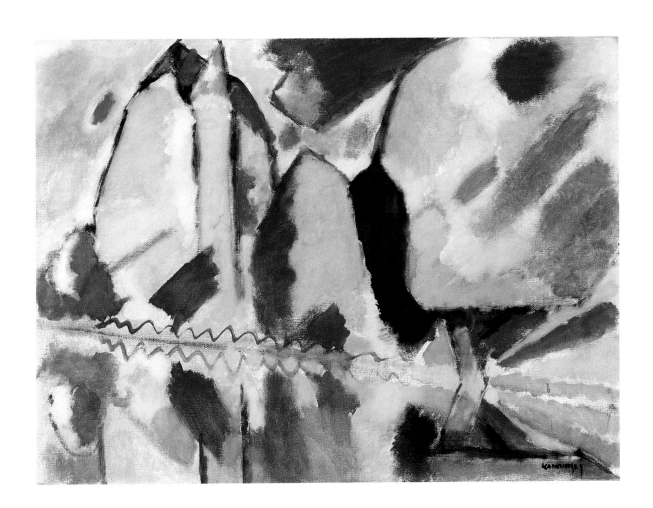

WASSILY KANDINSKY

b. 1866, Moscow, Russia. d. 1944, Neuilly-sur-Seine, France

Sketch I for Painting with White Border (Moscow), 1913

Oil on canvas. 39⅜ in.×30⅞ in. Gift from the estate of Katherine S. Dreier, 1953

Painting is like a thundering collision of different worlds that are destined in and through conflict to create that new world called the work. Technically, every work of art comes into being in the same way as the cosmos—by means of catastrophes, which ultimately create out of the cacophony of the various instruments that symphony we call the music of the spheres. The creation of the work of art is the creation of the world.

Wassily Kandinsky, 1913

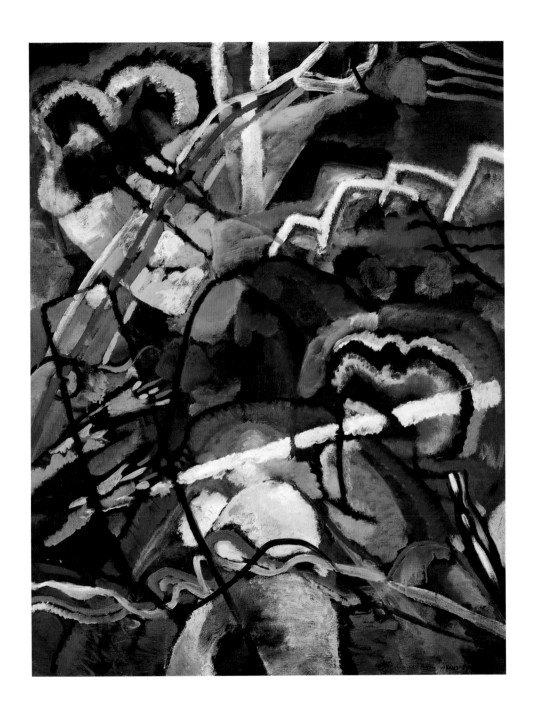

WASSILY KANDINSKY

b.1866, Moscow, Russia. d.1944, Neuilly-sur-Seine, France

Succession, 1935

Oil on canvas. 31 in.×39 in. Acquired 1944

Here lies the solution to the "abstract art" issue. Art remains silent only to those who are not able to "hear" the form. But! Not only the abstract, but each kind of art, however thoroughly "realistic" it may be. The "content" of painting is painting. Nothing has to be deciphered. The content, filled with happiness, speaks to that person to whom each is alive, i.e., has content. The person to whom the form "speaks" will not unconditionally look for "objects." I willingly admit that "objects" are a necessity of expression for many artists, but these objects remain something incidental to painting. Thus the conclusion follows that the objects do not necessarily have to be regarded as something inevitable in painting; they can just as well have a disturbing effect, which is what I feel they have in my painting.

Wassily Kandinsky, 1937

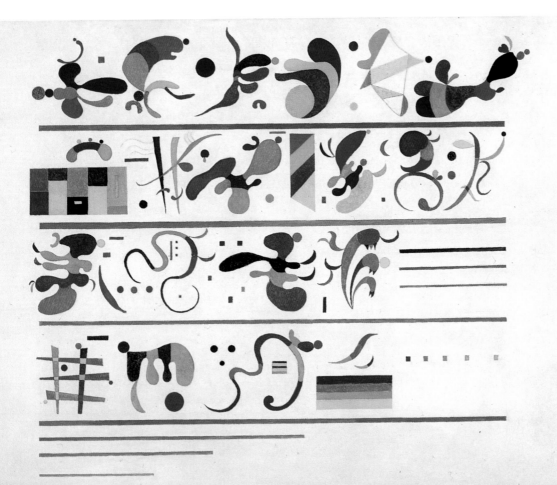

ROCKWELL KENT

b. 1882, Tarrytown Heights, New York. d. 1971, Plattsburg, New York

The Road Roller, 1909

Oil on canvas. 34⅛ in. × 44¼ in. Acquired 1918

Art is not art until it has effaced itself. Only when the blue paint of a sky ceases to be just color—becoming as it were depths of the sea—is that blue right, and truly beautiful. Only when green becomes the growing grass, or the earth colors land and rocks, when indigo becomes the ocean, and the colors of a figure become flesh and blood; only when words become ideas; when the sounds of music becomes images; only when every medium of the arts becomes transmuted into a portion of our living universe, only then is art consistent with the dignity of man.

Rockwell Kent, 1906

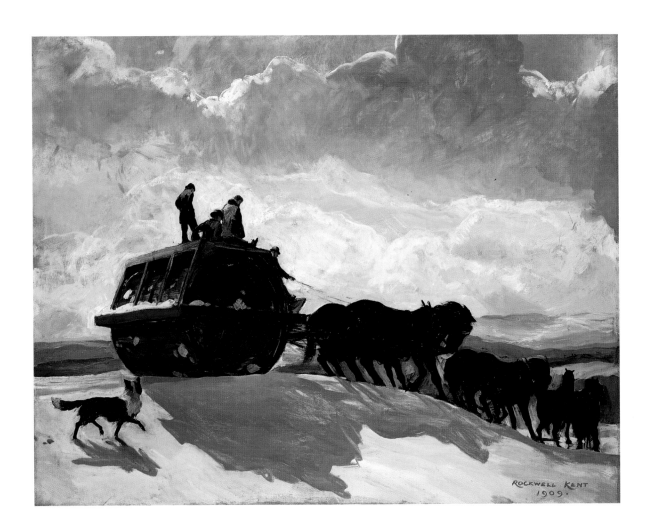

ROCKWELL KENT
1909.

PAUL KLEE

b. 1879, Münchenbuchsee, Switzerland. d. 1940, Muralto-Locarno, Switzerland

Tree Nursery, 1929

Oil on incised gesso on canvas. 17⅛ in. × 20⅝ in. Acquired 1930

It would never occur to anyone to demand of the tree that its top should be shaped just like its roots. Everyone knows that what is above ground cannot be just like its roots. It is obvious that different functions in different elemental domains will cause a considerable disparity. And yet the artist, like the trunk of the tree, is really doing nothing else than accumulate what comes up from the depths and pass it on. He neither serves nor commands; he is an intermediary.

Paul Klee, 1924

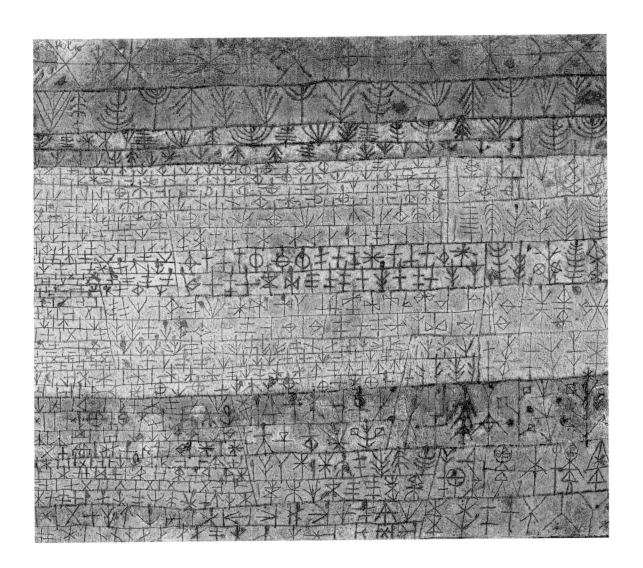

PAUL KLEE

b. 1879, Münchenbuchsee, Switzerland. d. 1940, Muralto-Locarno, Switzerland

Arab Song, 1932

Gouache on unprimed burlap. 35⅞ in.×25½ in. Acquired 1941

With only a raw canvas stained to a few pale tones, he evoked a hot sun, desert dust, faded clothes, veiled women, an exotic plant, a romantic interpretation of North Africa.

Duncan Phillips, 1941

This is what I search for all the time: to awaken sounds which slumber inside me, a small or large adventure in color.

Paul Klee, 1927

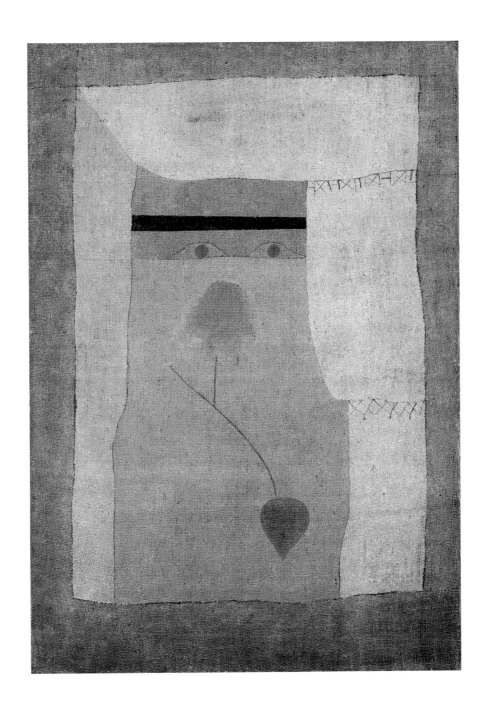

KARL KNATHS

b.1891, Eau Claire, Wisconsin. d.1971, Provincetown, Massachusetts

Cin-Zin, 1945

Oil on canvas. 24 in.×30 in. Acquired 1945

Knaths is a simple man, a man of profound goodness and integrity who reacts to thrills of artistic discovery, whether visual or technical, with the same zest for nature in its more untamed elements which attracts him to American folklore. He is dedicated to a life for which he was born with great purpose—to paint each canvas better and ever better until whatever it was that thrilled his inner eye transcends the colors he knows so well how to mix and manage. There is philosophy and nobility in the artist as in the man.

Duncan Phillips, 1957

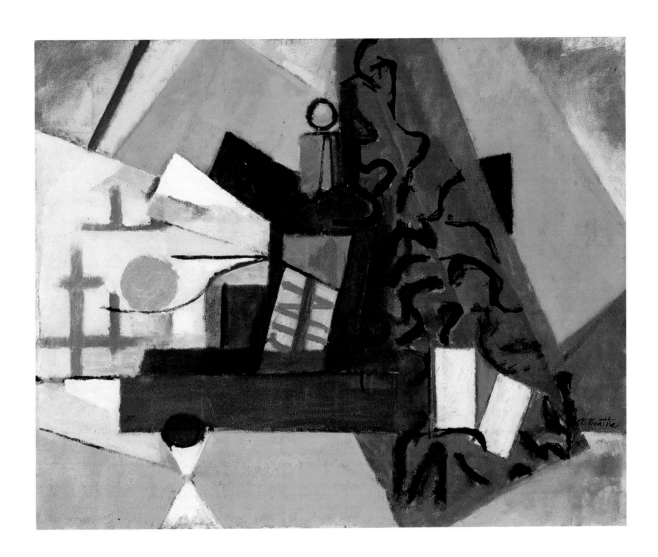

OSKAR KOKOSCHKA

b.1886, Pochlarn, Austria. d.1980, Montreux, Switzerland

Portrait of Lotte Franzos, 1909

Oil on canvas. 45¼ in.×31¼ in. Acquired 1941

Do you suppose that the person, as he or she affects me, stops short at the neck? Hair, hands, clothes, movements, are at least as important to me.... I do not paint anatomical specimens.

Oskar Kokoschka

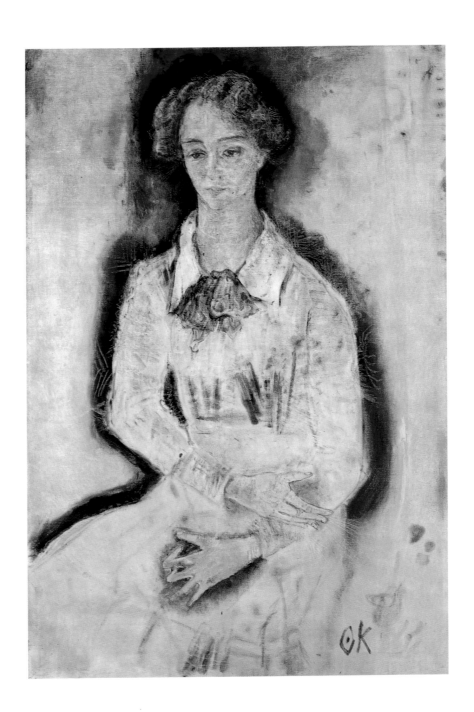

JACOB LAWRENCE

b. 1917, Atlantic City, New Jersey

The Migration Series, Panel No. 57, 1940–41

Tempera on masonite. 18 in.×12 in. Acquired 1942

I don't think about this series in terms of history. I think in terms of contemporary life. It was such a part of me I didn't think of something outside.... It was a portrait of myself, a portrait of my family, a portrait of my peers.... It was like a still life with bread, a still life with flowers. It was like a landscape you see.

Jacob Lawrence

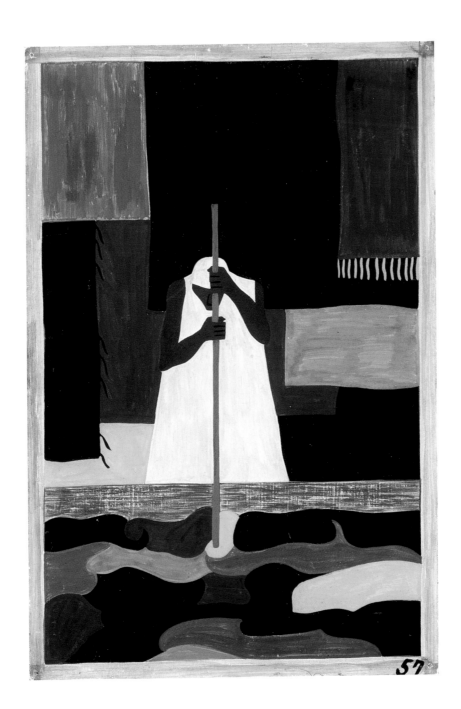

57

MORRIS LOUIS

b.1912, Baltimore, Maryland. d.1962, Washington, D.C.

Number 182, 1961

Acrylic on canvas. 82 in.×33 in. Acquired 1963

To be an artist takes not only courage but something more—you must be willing to expose yourself to ridicule.

Morris Louis, 1961

Louis spills his paint on unsized and unprimed cotton duck canvas, leaving the pigment almost everywhere thin enough, no matter how many different veils of it are superimposed, for the eye to sense the threadedness and wovenness of the fabric underneath. But "underneath" is the wrong word. The fabric, being soaked in paint rather than merely covered by it, becomes paint in itself, color in itself, like dyed cloth; the threadedness and wovenness are in the color.

Clement Greenberg, 1960

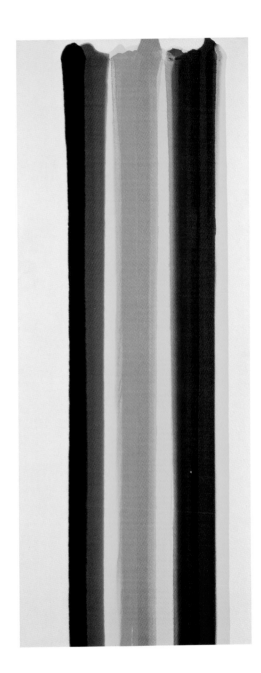

ÉDOUARD MANET

b.1832, Paris, France. d.1883, Paris, France

Spanish Ballet, 1862

Oil on canvas. 24 in.×35⅝ in. Acquired 1928

During the summer of 1862 a troupe of Spanish dancers triumphed at the Hippodrome in Paris. It was a success similar to that of the Russian Ballet of our own period. The painters were among the most enthusiastic admirers of the performance and young Édouard Manet was inspired to creative adventure with his already brilliant brush and a courageous color. He dared to ask the Spaniards to pose for him, singly and together, at his studio, and the results are important landmarks in the history of modern painting.

Duncan Phillips, 1929

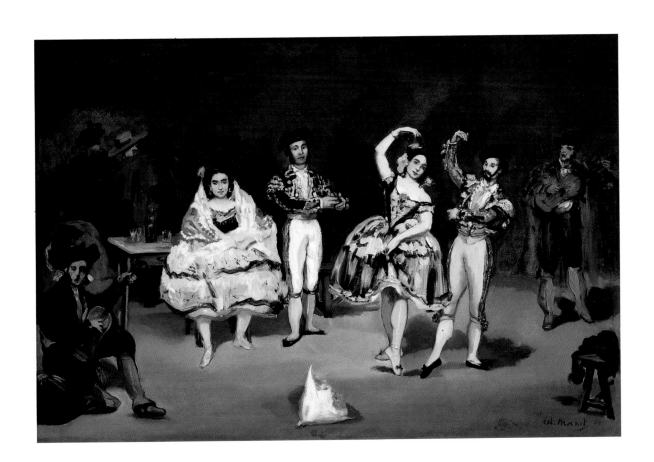

FRANZ MARC

b. 1880, Munich, Germany. d. 1916, Verdun, France

Deer in the Forest I, 1913

Oil on canvas. 39¾ in. × 41¼ in. Gift from the estate of Katherine S. Dreier, 1953

My instincts so far have not guided me too badly on the whole. . . . I especially mean the instinct that led me away from people to a feeling for animality, for the "pure beasts." People with their lack of piety, especially men, never touched my true feelings. But animals with their virginal sense of life awakened all that is good in me.

Franz Marc, 1914–15

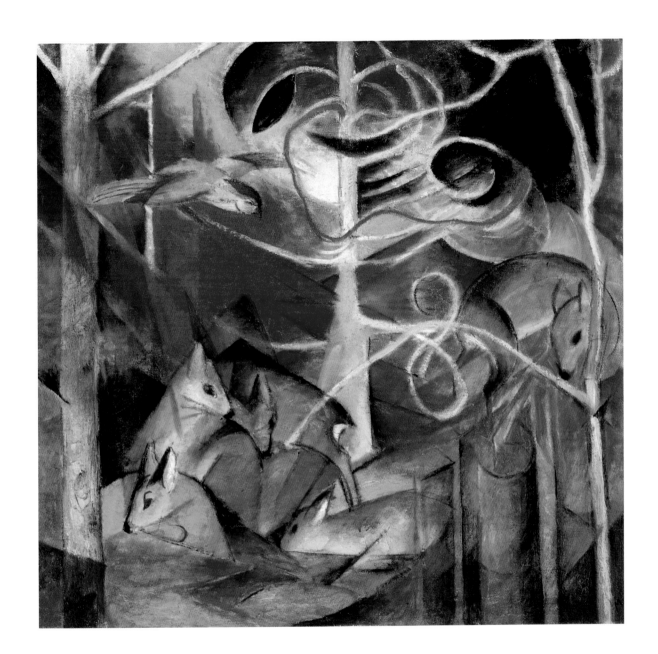

JOHN MARIN

b.1870, Rutherford, New Jersey. d.1953, Cape Split, Maine

Street Crossing, New York, 1928

Watercolor on paper. 26¼ in.×21¾ in. Acquired 1931

Shall we consider the life of a great city as confined simply to the people and animals on its streets and in its buildings? Are the buildings themselves dead? We have been told somewhere that a work of art is a thing alive. You cannot create a work of art unless the things you behold respond to something within you. Therefore if these buildings move me they too must have life. Thus, the whole city is alive; buildings, people, all are alive; and the more they move me the more I feel them to be alive. . . . And so I try to express graphically what a great city is doing. Within the frames there must be a balance, a controlling of these warring, pushing, pulling forces. This is what I am trying to realize.

John Marin, 1913

HENRI MATISSE

b. 1869, Le Cateau-Cambrésis, France. d. 1954, Nice, France

Studio, Quai St. Michel, 1916

Oil on canvas. 58¼ in.×46 in. Acquired 1940

Expression for me does not reside in passions glowing in a human face or manifested by violent movement. The entire arrangement of my picture is expressive: the place occupied by the figures, the empty spaces around them, the proportions, everything has its share. Composition is the art of arranging in a decorative manner the diverse elements at the painter's command to express his feelings.

Henri Matisse, 1908

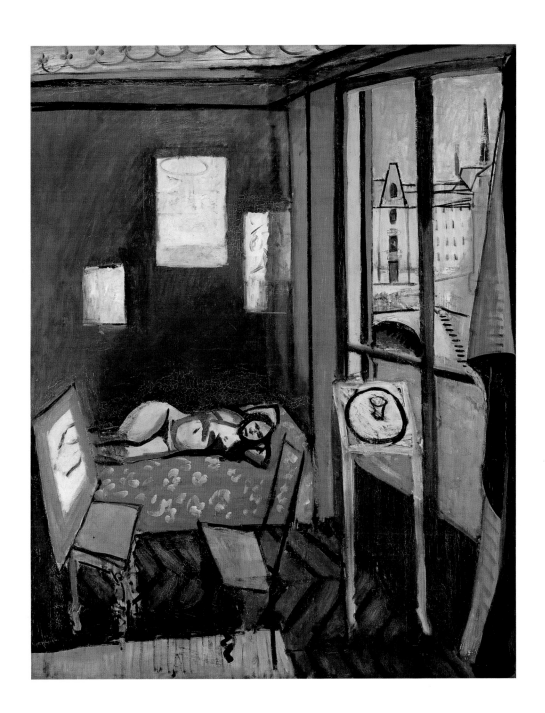

HENRI MATISSE

b.1869, Le Cateau-Cambrésis, France. d.1954, Nice, France

Interior with Egyptian Curtain, 1948

Oil on canvas. 45¾ in.×35⅛ in. Acquired 1950

Color, above all, and perhaps even more than drawing, is a means of liberation. Liberation is the freeing of conventions, old methods being pushed aside by the contributions of the new generation. . . . But drawing and colour are only a suggestion. By illusion, they must provoke a feeling of the property of things in the spectator, in so far as the artist can intuit this feeling, suggest it in his work and get it across to the viewer. An old Chinese proverb says: "When you draw a tree, you must feel yourself gradually growing with it."

Henri Matisse, 1945

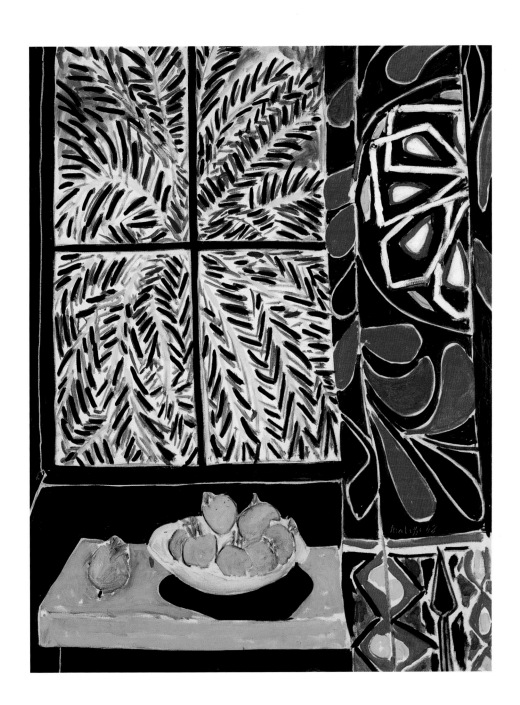

JOAN MIRÓ

b. 1893, Barcelona, Spain. d. 1983, Palma de Mallorca, Spain

The Red Sun, 1948

Oil on canvas. 35⅞ in.×28 in. Acquired 1951

Forms take reality for me as I work. In other words, rather than setting out to paint something, I begin painting and as I paint the picture begins to assert itself, or suggest itself under my brush. The form becomes a sign for a woman or a bird as I work.... Even a few casual wipes of my brush in cleaning it may suggest the beginning of a picture. The second stage, however, is carefully calculated. The first stage is free, unconscious; but after that the picture is controlled throughout.

<div align="right">Joan Miró, 1947</div>

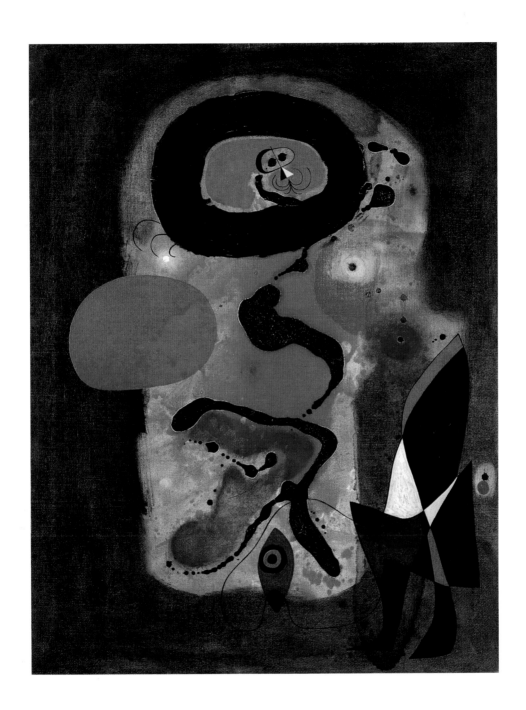

JOAN MITCHELL

b.1926, Chicago, Illinois. d.1992, Paris, France

August, Rue Daguerre, 1957

Oil on canvas. 82 in.×69 in. Acquired 1958

To see and to paint require awareness. Drawing makes you very conscious of what you are looking at. When I am working, I am only aware of the canvas and what it tells me to do. I am certainly not aware of myself. Painting is a way of forgetting oneself. Sometimes I am totally involved. It's like riding a bicycle with "no hands." I am in it. I am not there any more. It is a state of non-self-consciousness. It does not happen often. I am always hoping it might happen again. It's lovely.

Joan Mitchell, 1986

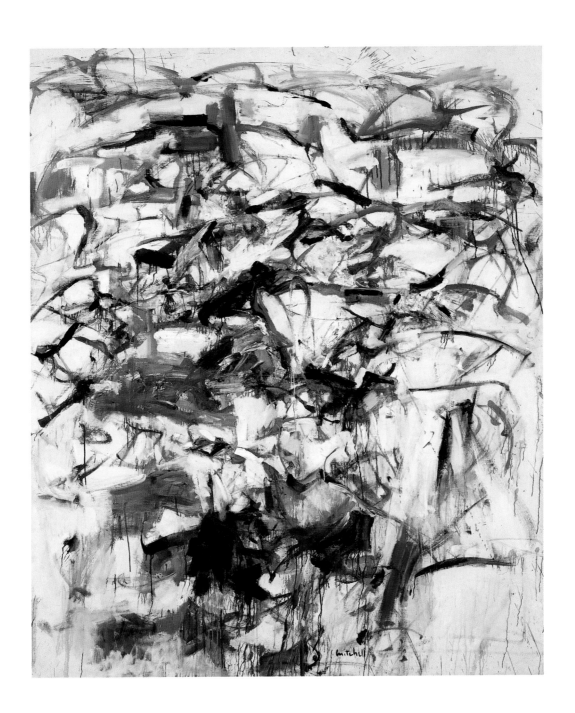

AMEDEO MODIGLIANI

b.1884, Livorno, Italy. d.1920, Paris, France

Elena Povolozky, 1917

Oil on canvas. 25½ in.×19¼ in. Acquired 1949

[Modigliani] reduced [his models] to his type, to the vision within him. . . . But this is only the means whereby the painter portrays his own image—not the physical appearance, but the mysterious lineaments of his genius; for Modigliani's portraits, even his self-portraits, are not the reflection of his external observation, but of his internal vision, of a vision as gracious, noble, acute and deadly as the fabulous horn of the Unicorn.

Jean Cocteau, 1950

Hold sacred everything that may exalt and stimulate your brains. . . . Try to provoke these fruitful stimuli, try to carry them out because they, and they alone, can spur intelligence on to the maximum of its creative power.

Amedeo Modigliani, circa 1901

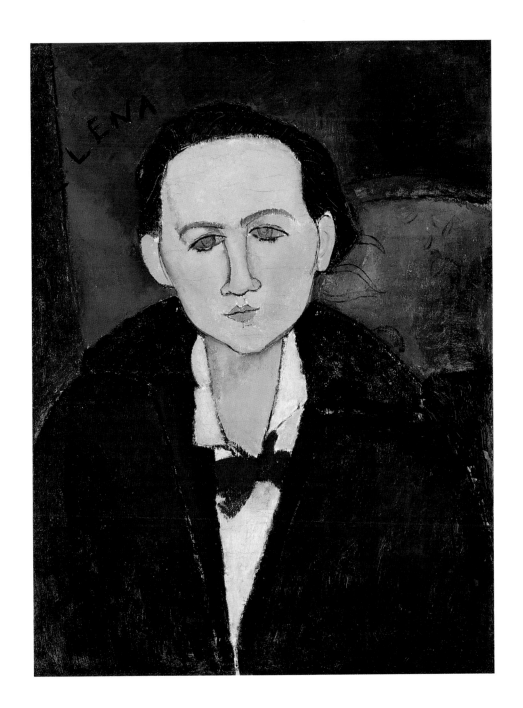

PIET MONDRIAN

b.1872, Amersfoort, The Netherlands. d.1944, New York, New York

Composition No. III, 1921–25

Oil on canvas. 19¼ in.×19¼ in. Acquired 1946

The cultivated man of today is gradually turning away from natural things, and his life is becoming more and more abstract. . . . Natural (external) things become more and more automatic, and we observe that our vital attention fastens more and more on internal things. The life of the truly modern man is neither purely materialistic nor purely emotional. It manifests itself rather as a more autonomous life of the human mind becoming conscious of itself. . . . It is the same with art. Art will become the product of another duality in man: the product of a cultivated externality and of an inwardness deepened and more conscious. As a pure representation of the human mind, art will express itself in an aesthetically purified, that is to say, abstract form.

Piet Mondrian, 1919

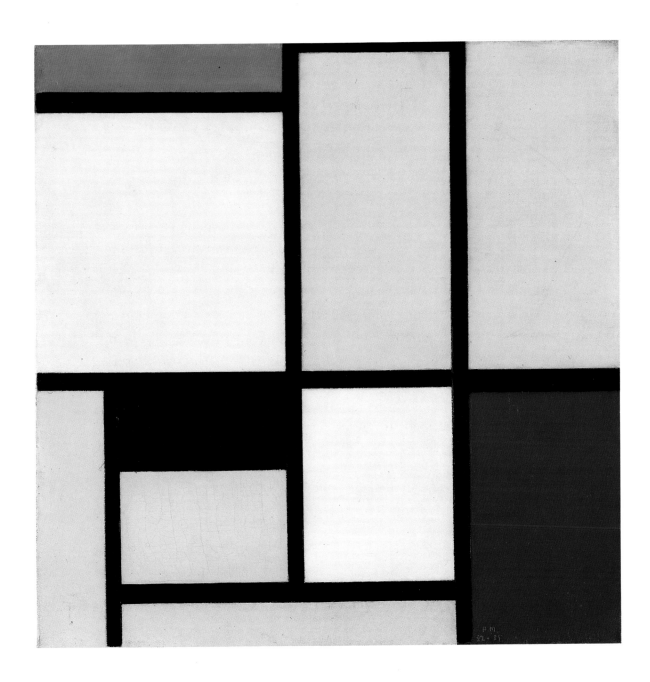

PIET MONDRIAN

b. 1872, Amersfoort, The Netherlands. d. 1944, New York, New York

Painting No. 9, 1939–42

Oil on canvas. 31¼ in. × 29⅛ in. Gift from the estate of Katherine S. Dreier, 1953

Through its simple means, pure abstract art can attain the objectivity of ornament, the purity of geometric construction, the spontaneity of the child. But to be art, the subjective must be manifested through the objective, the apparently mathematical must be free, spontaneity must be consciously expressed.

Piet Mondrian, 1929

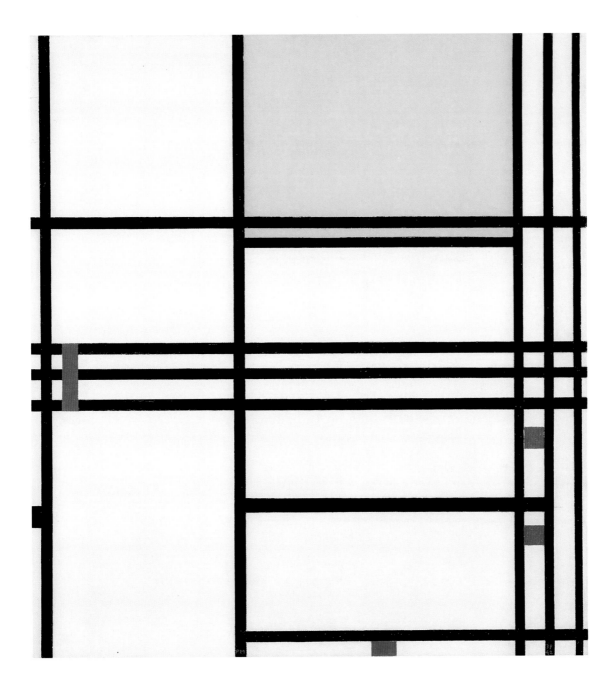

CLAUDE MONET

b.1840, Paris, France. d.1926, Giverny, France

Val-Saint-Nicholas, near Dieppe (Morning), 1897

Oil on canvas. 25⅝ in.×39⅜ in. Acquired 1959

I often followed Claude Monet in search of impressions. He was no longer a painter, in truth, but a hunter. He proceeded, followed by children who carried his canvases, five or six canvases representing the same subject at different times during the day and with different effects. He took them up and put them aside in turn, according to the changes in the sky. Before his subject, the painter lay in wait for the sun and shadows, capturing in a few brushstrokes the ray that fell or the cloud that passed. . . . I have seen him thus seize a glittering shower of light on the white cliff and fix it in a flood of yellow tones which, strangely, rendered the surprising and fugitive effect of that unseizable and dazzling brilliance. On another occasion he took a downpour beating on the sea in his hands and dashed it on the canvas—and indeed it was the rain that he had thus painted.

Guy de Maupassant, 1886

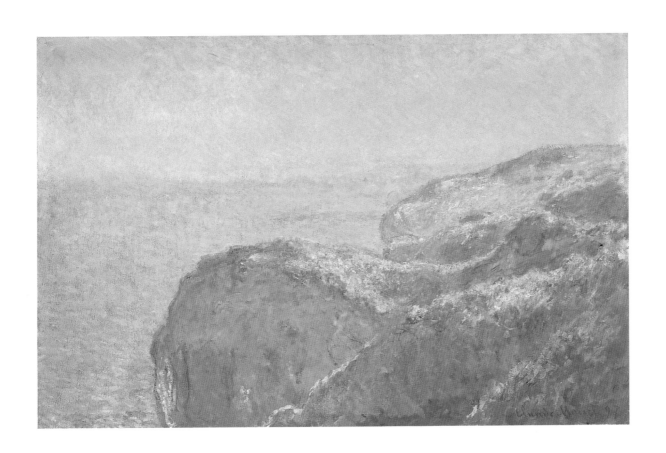

GIORGIO MORANDI

b. 1890, Bologna, Italy. d. 1964, Bologna, Italy

Still Life, 1953

Oil on canvas. 8 in.×15⅝ in. Acquired 1954

Giorgio Morandi searches and creates in great solitude. . . . He looks at a collection of objects on a table with the same emotions that stirred the heart of the traveller in ancient Greece when he gazed on the woods and valleys and mountains reputed to be the dwelling places of the most beautiful and marvellous deities. These objects are dead for us because they are immobile. But he looks at them with belief. He finds comfort in their inner structure—*their eternal aspect.*

Giorgio de Chirico

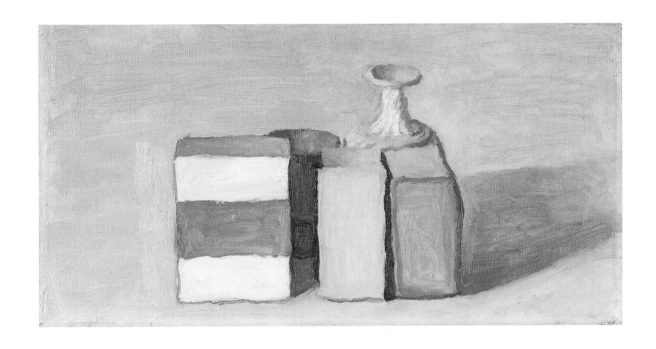

BERTHE MORISOT

b.1841, Bourges, France. d.1895, Paris, France

Two Girls, circa 1894

Oil on canvas. 26 in.×21½ in. Acquired 1925

The peculiarity of Berthe Morisot . . . was to live her painting and to paint her life, as if the interchange between seeing and rendering, between the light and her creative will, were to her a natural function, a necessary part of her daily life. She would take up the brush, leave it aside, take it up again, in the same way as a thought will come to us, vanish, and return. It is this which gives her works the very particular charm of a close and almost indissoluble relationship between the artist's ideals and the intimate details of her life. Her sketches and paintings keep closely in step with her development as a girl, wife, and mother. I am tempted to say that her work as a whole is like the diary of a woman who uses color and line as her means of expression.

Paul Valéry, 1941

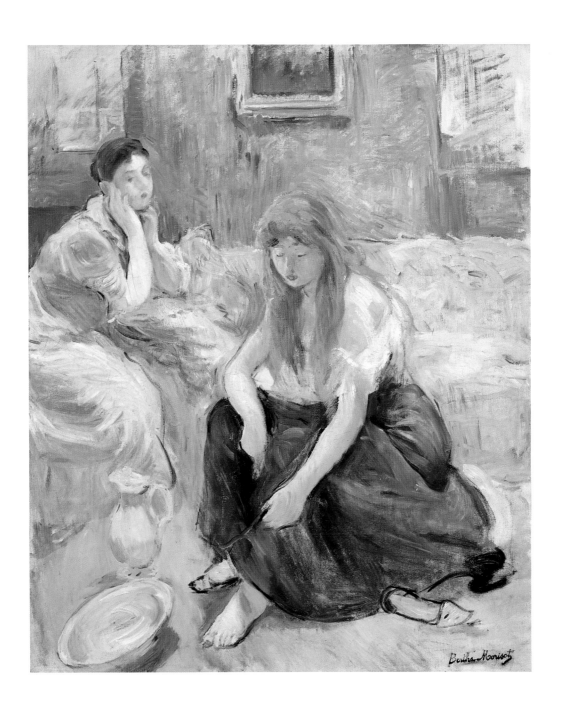

ROBERT MOTHERWELL

b. 1915, Aberdeen, Washington. d. 1991, Provincetown, Massachusetts

In White and Yellow Ochre, 1961

Oil, gouache, and paper collage on paper. 41 in.×27 in. Acquired 1965

If a painting does not make a human contact, it is nothing. But the audience is also responsible. Through pictures, our passions touch. Pictures are vehicles of passion, of all kinds and orders, not pretty luxuries like sports cars. In our society, the capacity to give and receive passion is limited. For this reason, the act of painting is a deep human necessity, not the production of a hand-made commodity. . . . True painting is a lot more than "picture-making." A man is neither a decoration nor an anecdote.

Robert Motherwell, 1955

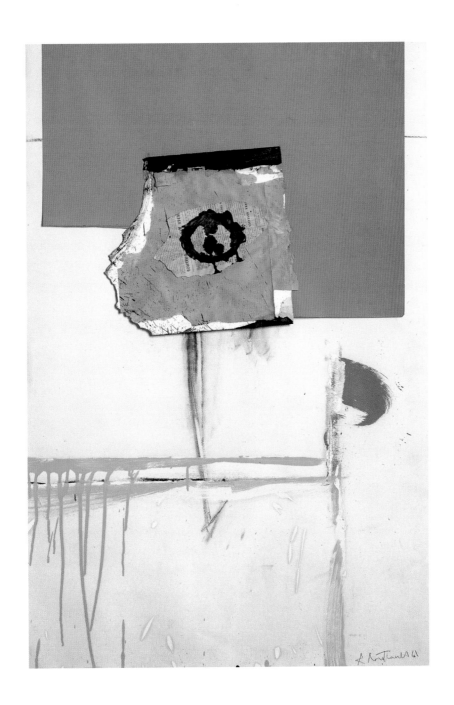

BEN NICHOLSON

b.1894, Denham, Buckinghamshire, England. d.1982, Hampstead, England

Still Life, March 17, 1950, 1950

Oil on canvas. 22 in.×24 in. Acquired 1956

It is only at the point at which a painting becomes an actual experience in the artist's life, more or less profound and more or less capable of application according to the artist's capacity to live, that it is capable of becoming a part also of the lives of other people, and that it can take its place in the structure of the world, in everyday life.

Ben Nicholson, 1937

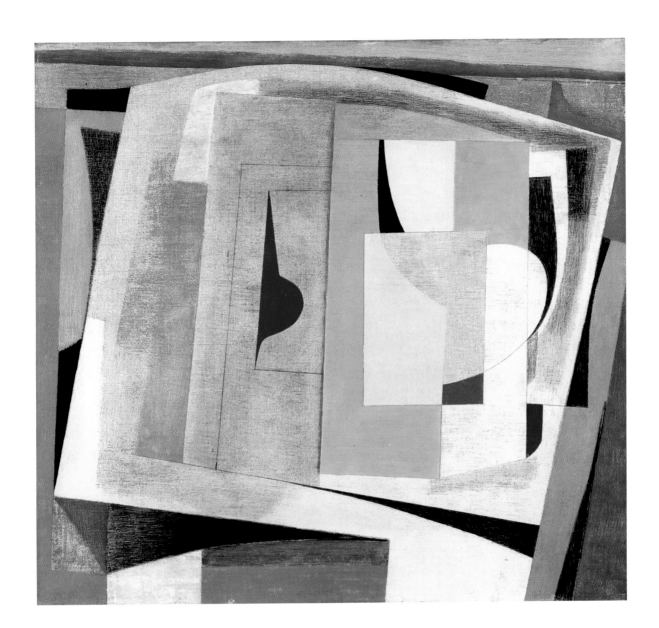

KENNETH NOLAND

b. 1924, Asheville, North Carolina

April, 1960

Acrylic on canvas. 16 in.×16 in. Acquired 1960

When you play back and forth between the arbitrariness and the strictness of the conditions of making pictures it's a very delicate threshold back and forth. . . . But you can plan the conditions for color ahead . . . you can get together . . . all the frames of reference that will get you into the condition of using color in relation to shape, to size, to focus, to depth, to tactility.

Kenneth Noland, 1971

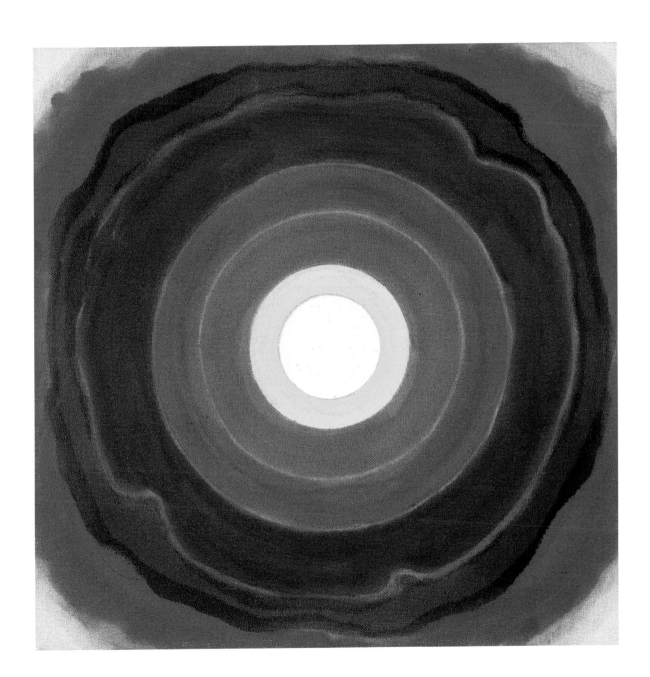

GEORGIA O'KEEFFE

b.1887, Sun Prairie, Wisconsin. d.1986, Santa Fe, New Mexico

Pattern of Leaves, circa 1923

Oil on canvas. 22⅛ in.×18⅛ in. Acquired 1926

Nothing is less real than realism. Details are confusing. It is only by selection, by elimination, by emphasis, that we get at the real meaning of things.

Georgia O'Keeffe, 1922

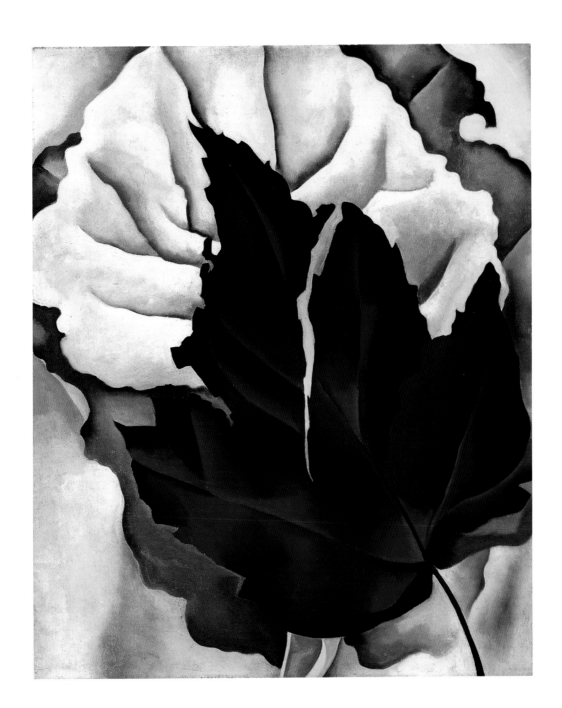

GEORGIA O'KEEFFE

b. 1887, Sun Prairie, Wisconsin. d. 1986, Santa Fe, New Mexico

Ranchos Church, 1929

Oil on canvas. 24 in.×36 in. Acquired 1930

The Ranchos de Taos Church is one of the most beautiful buildings left in the United States by the early Spaniards. Most artists who spend any time in Taos have to paint it, I suppose, just as they have to paint a self-portrait. I had to paint it—the back of it several times, the front once. . . . And I long ago came to the conclusion that even if I could put down accurately the thing I saw and enjoyed, it would not give the observer the kind of feeling it gave me. I had to create an equivalent for what I felt about what I was looking at—not copy it.

Georgia O'Keeffe, 1976

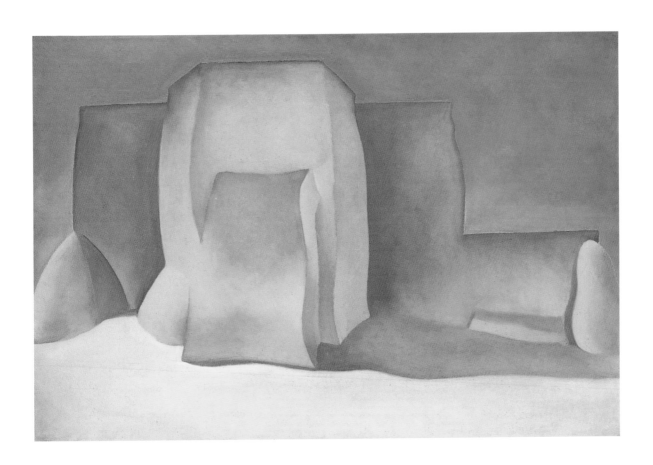

GUY PÈNE DU BOIS

b. 1884, Brooklyn, New York. d. 1958, Boston, Massachusetts

Blue Armchair, 1923

Oil on plywood panel. 25 in.×20 in. Acquired by 1930

I feel more and more that my pictures must seek interest in the faces and forms of people. I am not a landscape painter though I insist continually that I am any kind of painter I want to be. I have never been able to explain my inability to produce good landscapes. It is not entirely a lack of interest in landscape.... I am drawn to individuals rather than to masses.

Guy Pène du Bois, 1913

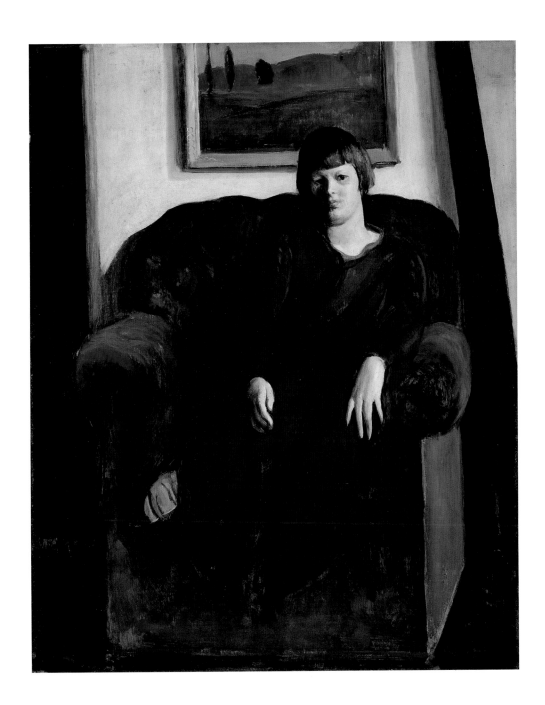

MARJORIE PHILLIPS

b. 1894, Bourbon, Indiana. d. 1985, Washington, D.C.

Night Baseball, 1951

Oil on canvas. 24¼ in. × 36 in. Acquired 1951 or 1952

Of course the central interest is Joe DiMaggio as he waits for the ball about to be pitched. His elegant superanimated stance has great style. I always loved that group of three: the squatting catcher just behind the man at bat and, standing behind him, the eagerly watching umpire leaning forward with responsibility of decision. . . . I would always make some pencil drawings of the grandstands, the dugout with players waiting, the plan of the baseball diamond. . . . This final version of my studies must have seemed authentic because years later . . . a man from Wildenstein's in New York wanted to buy it for the Baseball Hall of Fame in Cooperstown, New York. I said I could not sell it as I had given it to my husband.

Marjorie Phillips, circa 1985

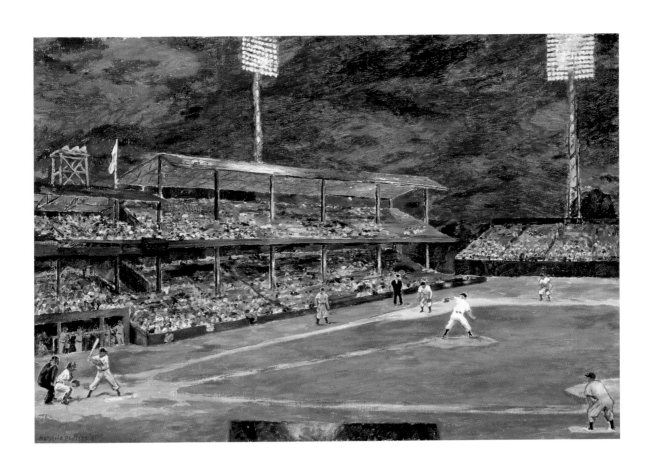

PABLO PICASSO

b. 1881, Malaga, Spain. d. 1973, Mougins, France

The Blue Room, 1901

Oil on canvas. 19⅞ in. × 24¼ in. Acquired 1927

He is still chasing originality, and while he is suddenly so smitten with El Greco that he hangs photographs of the Master's incredible paintings all around his bedroom, he breaks new ground with his "blue period." Works of that time are now much sought after by collectors. At another point, Picasso imitated Puvis de Chavannes. I know collectors of that period too, but I have to admit, the blue period has the edge.

Gustave Coquiot, 1914

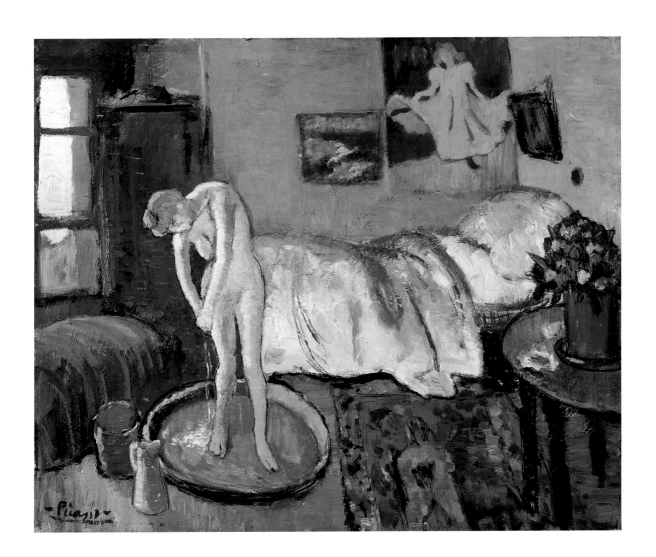

PABLO PICASSO

b.1881, Malaga, Spain. d.1973, Mougins, France

Bullfight, 1934

Oil on canvas. 19⅝ in.×25¾ in. Acquired 1937

A picture is not thought out and settled beforehand. While it is being done it changes as one's thoughts change. And when it is finished, it still goes on changing, according to the state of mind of whoever is looking at it. A picture lives a life like a living creature, undergoing the changes imposed on us by our life from day to day. This is natural enough, as the picture lives only through the man who is looking at it.

Pablo Picasso, 1935

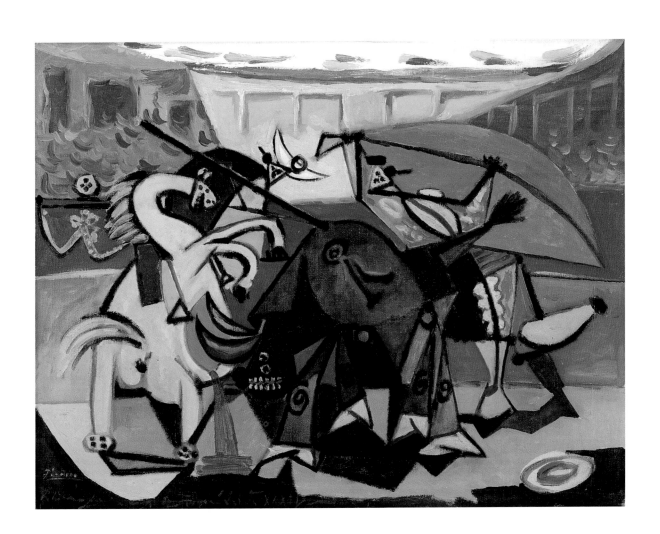

PABLO PICASSO

b. 1881, Malaga, Spain. d. 1973, Mougins, France

Woman with Green Hat, 1939

Oil on canvas. 25⅝ in.×19¾ in. Gift of the Carey Walker Foundation, 1994

Constantly on his guard against the onslaught of reality, he evades it with marvellous skill, teasing it with mocking interpretations and in a few days running through all the plastic resources at his command. Eluding the sentimental snares presented by the tenderest object, he hovers over it like a god of irreverence and instability, an incorruptible workman who is never taken unawares.

André Lhote, 1939

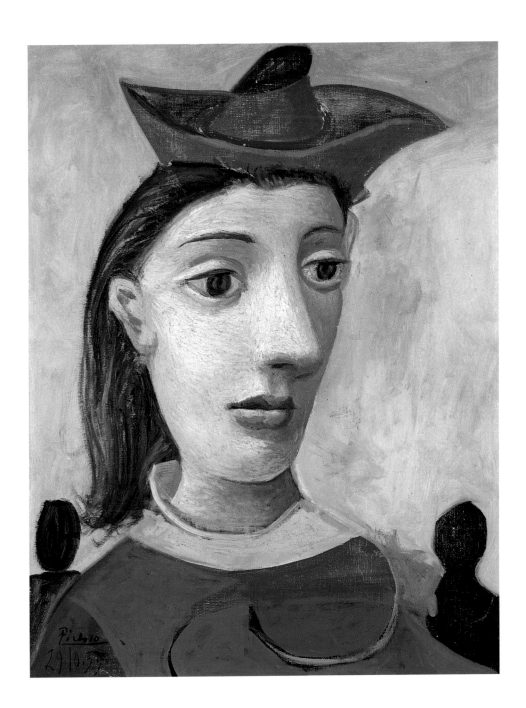

HORACE PIPPIN

b.1888, West Chester, Pennsylvania. d.1946, West Chester, Pennsylvania

Domino Players, 1943

Oil on composition board. 12¾ in.×22 in. Acquired 1943

How I paint. . . . The colors are very simple such as brown, amber, yellow, black, white, and green. The pictures which I have already painted come to me in my mind, and if to me it is a worthwhile picture, I paint it. I go over that picture in my mind several times and when I am ready to paint it I have all the details I need. I take my time and examine every coat of paint carefully and to be sure that the exact colors which I have in mind are satisfactory to me. Then I work my foreground from the background. That throws the background away from the foreground. In other words bringing out my work.

Horace Pippin, 1938

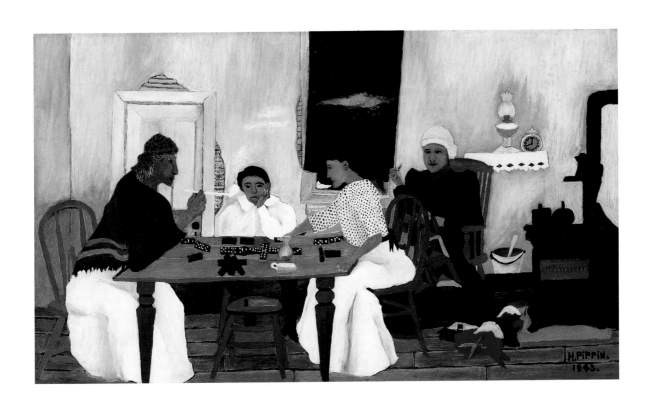

JACKSON POLLOCK

b.1912, Cody, Wyoming. d.1956, East Hampton, New York

Collage and Oil, circa 1951

Oil, ink, and paper collage on canvas. 50 in.×35 in. Acquired 1958

Modern art . . . is nothing more than the expression of contemporary aims. . . . All cultures have had means and techniques of expressing their immediate aims—the Chinese, the Renaissance, all cultures. The thing that interests me is that today painters do not have to go to a subject matter outside of themselves. Most modern painters work from a different source. They work from within. . . . And the modern artists have found new ways and new means of making their statements. It seems to me that the modern painter cannot express this age, the airplane, the atom bomb, the radio, in the old forms of the Renaissance or of any other past culture. Each age finds its own technique. . . . The strangeness will wear off and I think we will discover the deeper meanings in modern art.

Jackson Pollock, 1951

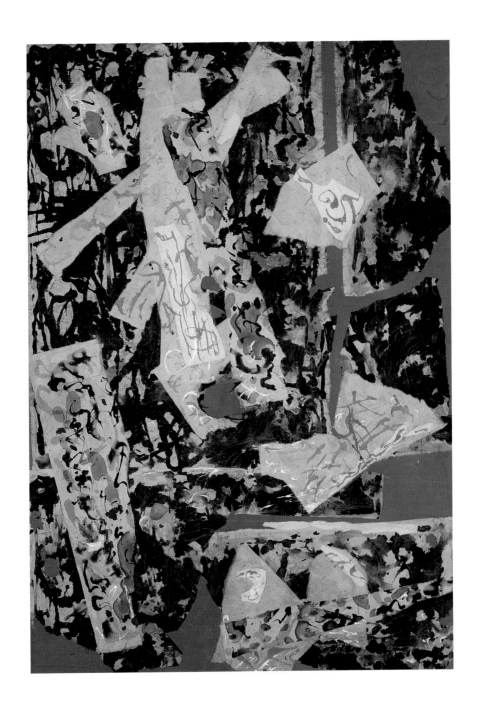

MAURICE PRENDERGAST

b.1858, St. John's, Newfoundland, Canada. d.1924, New York, New York

Ponte della Paglia, 1898–99 and 1922

Oil on canvas. 28 in.×23 in. Acquired 1922

His was the soul of the true artist, delighting in life, seeing it in his own way, believing that an artist's special agency is to communicate a life-enhancing pleasure by speaking to the senses and to the spirit in the same language. Prendergast proved that it is possible to be abstract in style and at the same time intimate in self-revelation. . . . He was so much of a purist in regard to the fusion or synthesis of the decorative and representative functions of his art of painting that he persisted in reducing his observations of the visible world and his joyous emotions in the presence of Nature, to a simple but beautifully organized pictorial pattern. He had a very definite something to say about life, but he never compromised with his faith by saying it in any other way than the painter's way, the way of form and color. Duncan Phillips, 1924

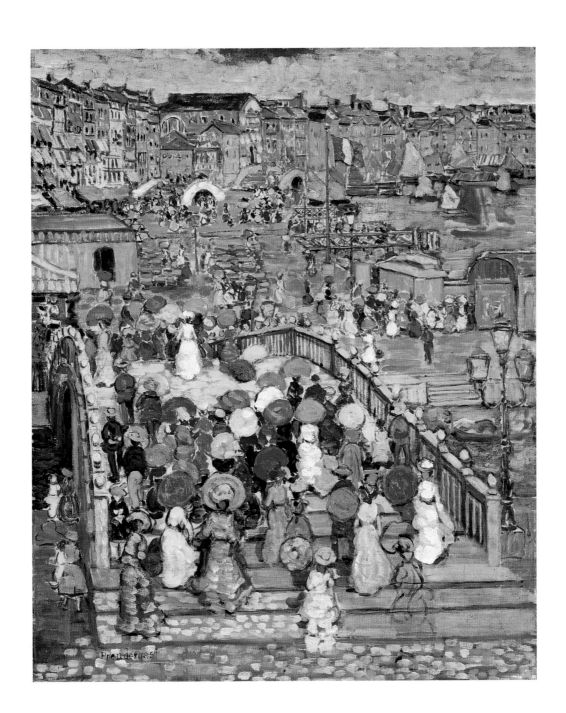

PIERRE-AUGUSTE RENOIR

b.1841, Limoges, France. d.1919, Cagnes-sur-Mer, France

Luncheon of the Boating Party, 1880–81

Oil on canvas. 51 in.×68 in. Acquired 1923

Out of doors there is a greater variety of light than in the studio, where, to all intents and purposes, it is constant; but, for just that reason, light plays too great a part outdoors; you have no time to work out the composition; you can't see what you are doing. I remember a white wall which reflected on my canvas one day while I was painting; I keyed down the color to no purpose—everything I put on was too light; but when I took it back to the studio, the picture looked black.... If the painter works directly from nature, he ultimately looks for nothing but momentary effects; he does not try to compose, and soon he gets monotonous.... It is not enough for a painter to be a clever craftsman; he must also love to "caress" his canvas, too.

Pierre-Auguste Renoir, circa 1883

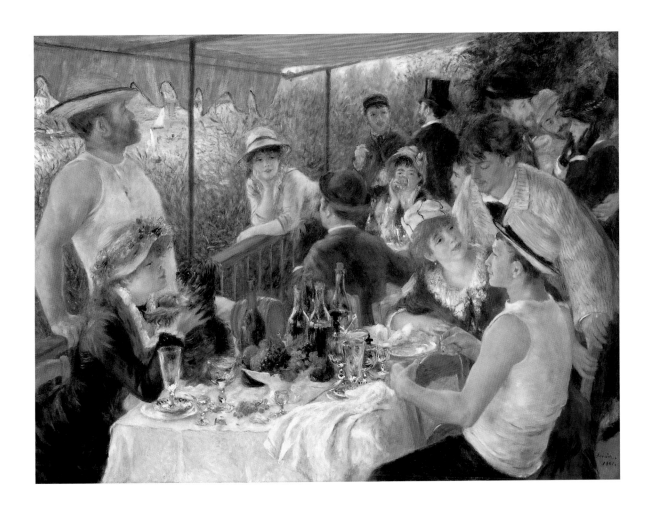

MARK ROTHKO

b.1903, Dvinsk, Russia. d.1970, New York, New York

Green and Maroon, 1953

Oil on canvas. 91¼ in.×54¾ in. Acquired 1957

A picture lives by companionship, expanding and quickening in the eyes of the sensitive observer. It dies by the same token.

Mark Rothko, 1947

The reason I paint them [large paintings] is precisely because I want to be very intimate and human. . . . However you paint the larger picture, you are in it. It isn't something you command.

Mark Rothko, 1951

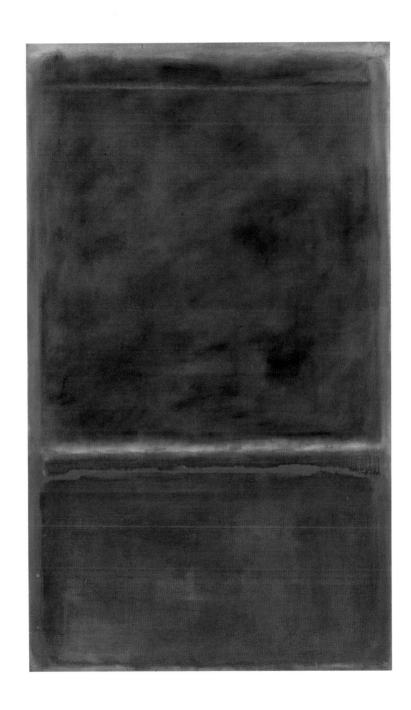

GEORGES ROUAULT

b.1871, Paris, France. d.1958, Paris, France

Circus Trio, 1924

Oil on paper mounted on cardboard. 29½ in.×41½ in. Acquired 1933

Often pagans, with their eyes wide open, do not see very clearly. How they have dinned their decorative art into our ears! There is no such thing as decorative art, but only art, intimate, heroic, or epic. We are far removed from the great fresco painters of the past, beside whom we often appear so small, but in every well-found work there will always be an arabesque of rhythm—which will not prevent fine and subtle relationships of texture.

Georges Rouault, 1937

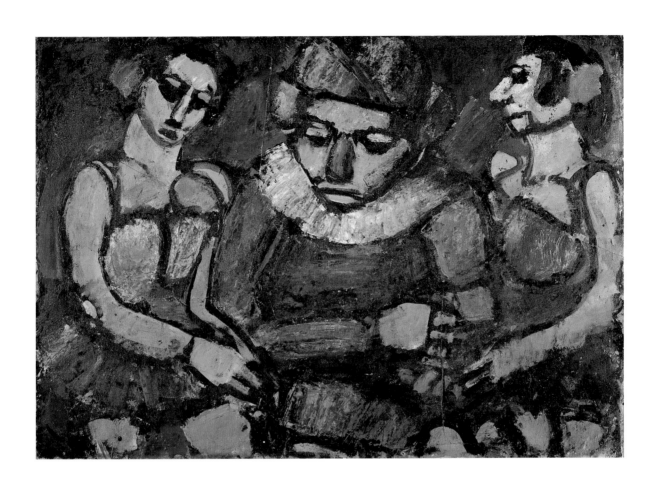

HENRI ROUSSEAU

b.1844, Laval, France. d.1910, Paris, France

Notre Dame, 1909

Oil on canvas. 13 in.×16 in. Acquired 1930

A round-shouldered genial old man, small of stature with a smiling face and bright eyes, carrying a cane, entered the room. He was warmly received, and one could see that he was pleased to find himself among so many admirers.... On my way home from this first visit, which I shall never forget as long as I live, I felt I had been favored by the Gods to meet one of the most inspiring and precious personalities of Paris.... By a sacred sense of privacy he was shielded from snobbery, pretense, and sophistication which was rife in the art circles of the time.... There is nothing chameleon about him.

Max Weber, 1942

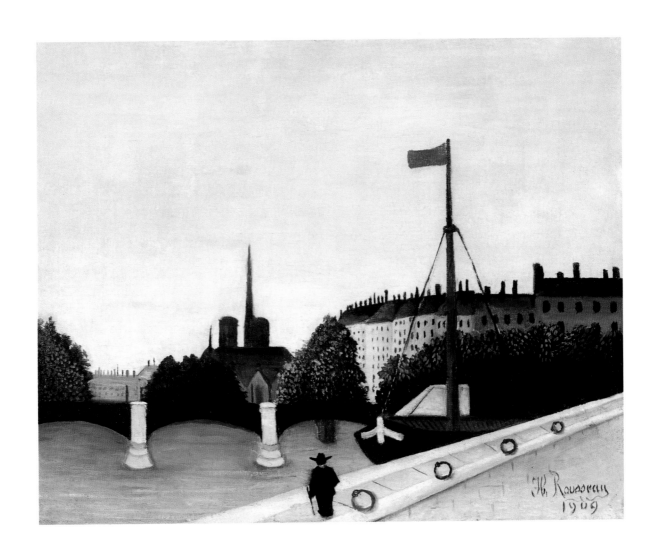

ALBERT PINKHAM RYDER

b.1847, New Bedford, Massachusetts. d.1917, Elmhurst, New York

Moonlit Cove, early 1880s

Oil on canvas. 14⅛ in.×17⅛ in. Acquired 1924

The artist should fear to become the slave of detail. He should strive to express his thought and not the surface of it. What avails a storm cloud accurate in form and color if the storm is not therein?

Albert Pinkham Ryder, 1905

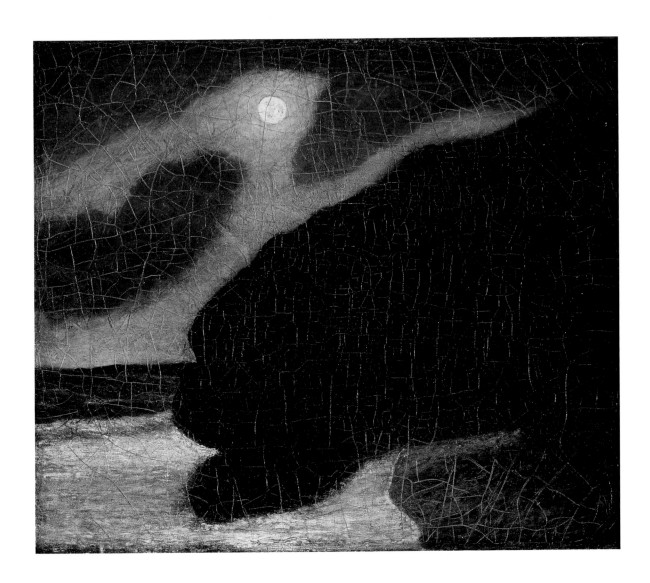

ALBERT PINKHAM RYDER

b. 1847, New Bedford, Massachusetts. d. 1917, Elmhurst, New York

Dead Bird, 1890s

Oil on wood panel. 4⅛ in.×10 in. Acquired 1928

Ryder gave us first and last an incomparable sense of pattern and austerity of mood. He saw with all too pitiless and pitiful an eye the element of helplessness in things, the complete succumbing of things in nature to those elements greater than they that wield a fatal power. Ryder was the last of the romantics, the last of a great school of artistry, as he was the first of our real painters and the greatest in vision. He was a still companion of Blake in that realm of beyond, the first citizen of the land of Luthany. He knew the fine distinction between drama and tragedy, the tragedy which nature prevails upon the sensitive to accept. He was the painter poet of the immanent in things.

Marsden Hartley, 1921

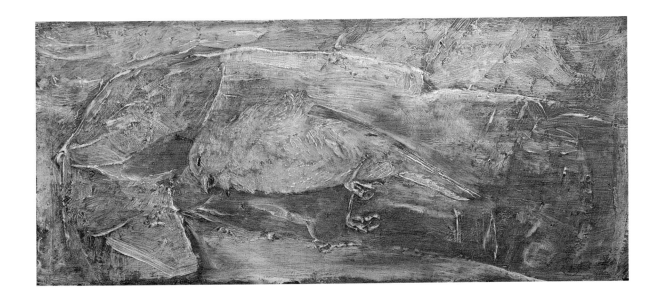

KURT SCHWITTERS

b.1887, Hanover, Germany. d.1948, Ambleside, England

Radiating World, 1920

Oil and paper collage on cardboard. 37½ in.×26¾ in.

Gift of the estate of Katherine S. Dreier, 1953

When he walked on the street, he would pick up threads, papers, pieces of glass—the discarded royalties of vacant lots—so that in his house there were piles of little sticks and pieces of wood, tufts of hair, old rags, disused unrecognizable objects, all of which were like fragments of life itself.... Schwitters' work seems to be endowed with the unreasonableness of dreams.

Georges Hugnet, 1937

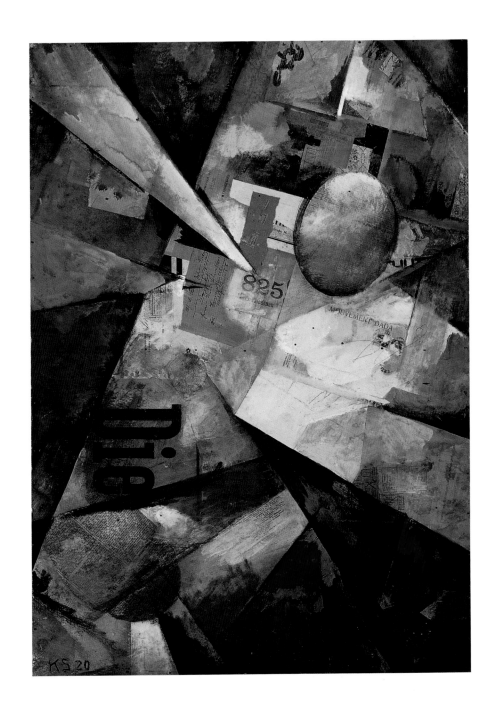

GEORGES SEURAT

b. 1859, Paris, France. d. 1891, Paris, France

The Stone Breaker, 1882

Oil on wood panel. 6¾ in.×10¼ in. Acquired 1940

From the first evening I met him, I discovered that his soul was also one of times past.... He believed in the powers of theories, in the absolute value of methods, and in the continuance of revolutions. I was very happy to find in a corner of Montmartre such an admirable example of a race which I had supposed extinct, a race of painter-theorists who combine idea and practice, unconscious fantasy and deliberate effort. Yes, I very clearly felt Seurat's kinship with the Leonardos, the Dürers, the Poussins.... He wanted to make a more logical art out of painting, more systematic, where less room would be left for chance effect. Just as there are rules of technique, he also wanted there to be [rules] for the conception, composition, and expression of subjects, understanding well that personal inspiration would suffer no more from these rules than from others.

Teodor de Wyzewa, 1891

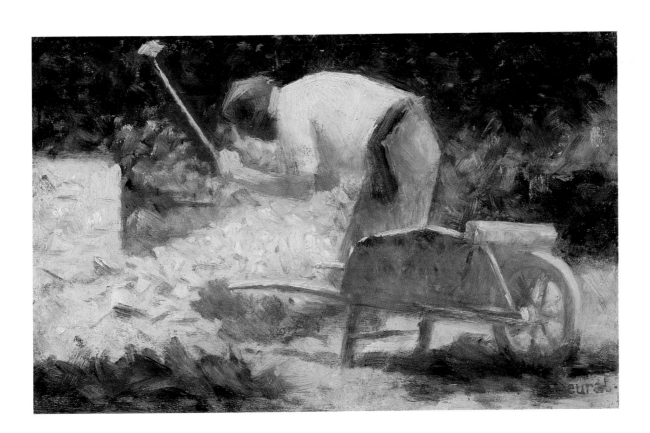

CHARLES SHEELER

b.1883, Philadelphia, Pennsylvania. d.1965, Dobbs Ferry, New York

Skyscrapers, 1922

Oil on canvas. 20 in.×13 in. Acquired 1926

Photography is nature seen from the eyes outward, painting from the eyes inward. Photography records inalterably the single image while painting records a plurality of images willfully directed by the artist.

Charles Sheeler, 1937

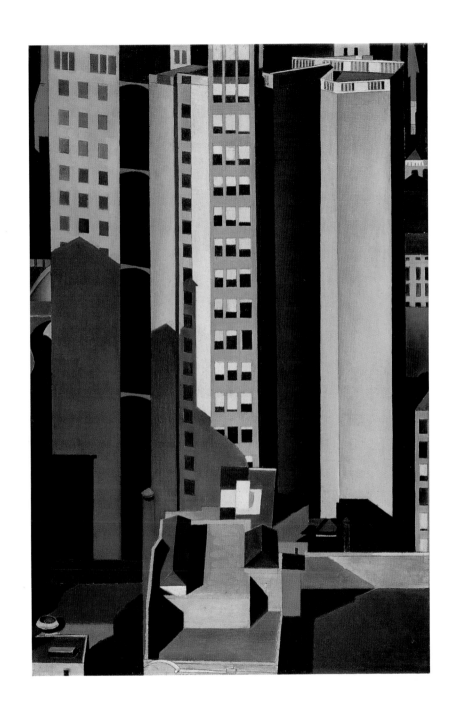

WALTER SICKERT

b.1860, Munich, Germany. d.1942, Bath, England

Ludovico Magno, 1930–31

Oil on canvas. 21½×30 in. Acquired 1941

Economy of means is a sign of the greatest craftsmanship in art. . . . One of the delights of art is the joy of seeing an effect produced with an economy of means. Quality in paint results from a natural gift together with study and practice. These will give a nonchalance, a looseness, a rapidity, which in themselves are of great beauty.

<div align="right">Walter Sickert, 1923–24</div>

The colours are light and airy except for the very dark green Homburg in the foreground and a splash of crimson—the Sickert trademark—among the old cloths liturgically flapping their *Sic transit.*

<div align="right">Cyril Connolly, 1932</div>

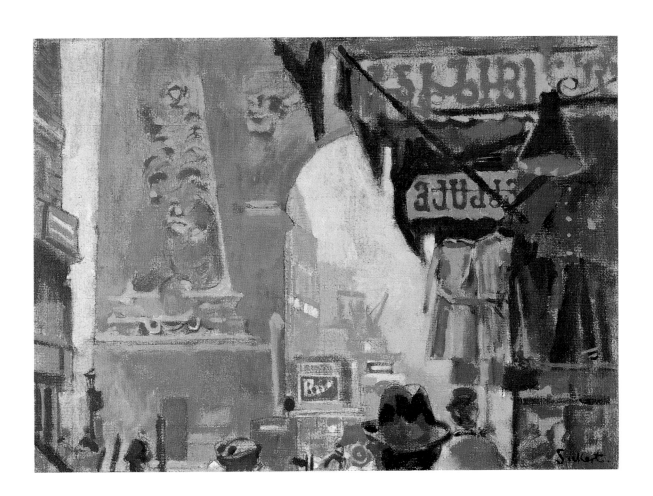

ALFRED SISLEY

b. 1839, Paris, France. d. 1899, Moret-sur-Loing, France

Snow at Louveciennes, 1874

Oil on canvas. 22 in.×18 in. Acquired 1923

I am for diversity of techniques in the same picture. Objects must be rendered so as to indicate their individual textures; in addition, and above all, they must be enveloped in light, as they are in nature.

Alfred Sisley, 1892

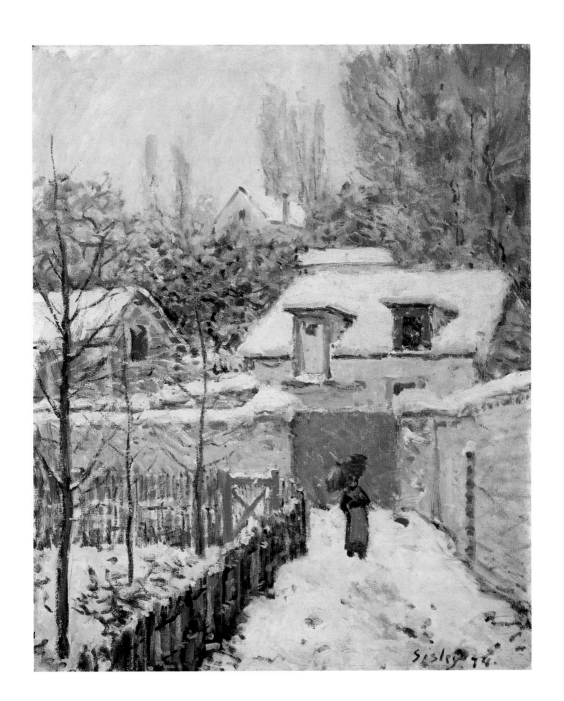

JOHN SLOAN

b.1871, Lock Haven, Pennsylvania. d.1951, Hanover, New Hampshire

Six O'Clock, Winter, 1912

Oil on canvas. 26 in.×32 in. Acquired 1922

Nature: atoms, plants, animals, humans, inorganic things—the whole universe; life around us: cities and mountains, plains and rivers; cloud and sky; the oceans; fire and sunlight; the table and dishes we eat from every day—all is nature: the artist's subject matter. There is no image that was not derived from a memory of something seen.

John Sloan, 1939

The Third Avenue elevated structure near Eighteenth Street. An average New York crowd disperses from work. The last rays of the winter sun affect only the sky.... Painted from memory.

John Sloan, 1938

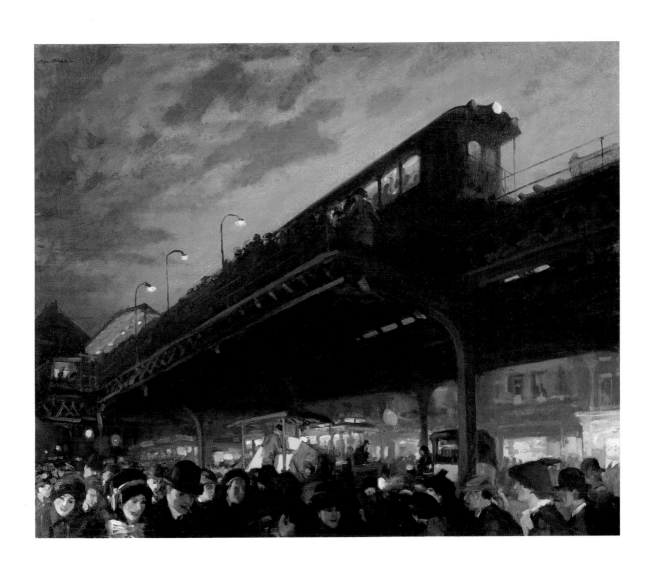

CHAIM SOUTINE

b.1893, Smilovitchi, Lithuania. d.1943, Paris, France

Return from School After the Storm, circa 1939

Oil on canvas. 17 in.×19½ in. Acquired 1940

Soutine set off in search of any trees worth painting. At last he found a subject. As usual, he looked at the subject at least ten times before deciding to paint it. He went, came back, returned and made so much commotion running back and forth between our house and the trees that it aroused the attention of the police who thought he must be a dangerous madman.

Mademoiselle Garde, circa 1956–57

The rapidity of execution was incredible. He would harbor an idea for months, then take up his brushes, abandoning them only when his canvas was finished.

Chana Orloff, 1951

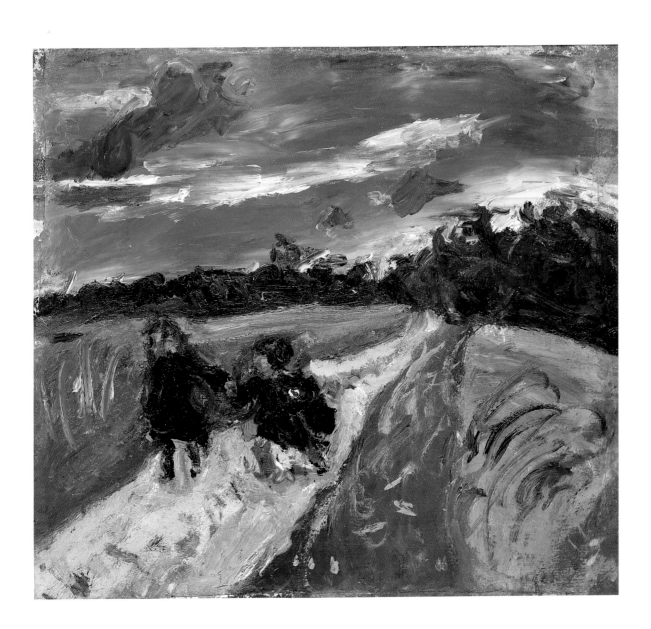

NICOLAS DE STAËL

b. 1914, St. Petersburg, Russia. d. 1955, Antibes, France

Fugue, 1951–52

Oil on canvas. 31¾ in.×39½ in. Acquired 1952. 1809

I do not set up abstract painting in opposition to figurative. A painting should be both abstract and figurative: abstract to the extent that it is a flat surface, figurative to the extent that it is a representation of space.

Nicolas de Staël

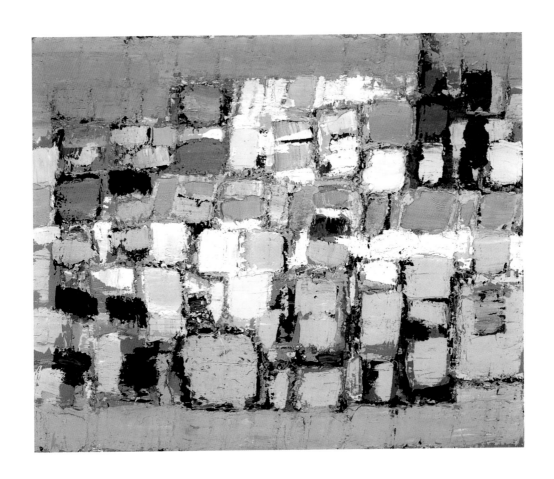

CLYFFORD STILL

b.1904, Grandin, North Dakota. d.1980, Baltimore, Maryland

1950 B, 1950

Oil on canvas. 83½ in.×67⅝ in. Acquired 1969

One thing is certain. I stand in opposition to almost everything I have heard and seen by these men who would take me in and integrate, or obliterate me. I refuse to be seduced by their social blarney, their measured cities, their repetitious devices, or their invitation to compromise. Christ, I have spent much of my life fighting the assembly line! Why should I accept their comfortable prisons of convenience because they package them in ideology for sentimentalism and shower-bath plastics? All I ask is that they shelter me from the rain. I will take care of my soul.

Clyfford Still, 1951

AUGUSTUS VINCENT TACK

b.1870, Pittsburgh, Pennsylvania. d.1949, Deerfield, Massachusetts

Night, Amargosa Desert, early 1930s

Oil on canvas on plywood panel. 83¾ in.×48 in. Acquired 1937

I have been developing some compositions of form and colors based on essential rhythm and to my mind they are the most interesting things I have so far accomplished. They are abstractly decorative, at the same time combining a deep mystical meaning which stimulates the imagination. It was given to the ancients to express the emotion of serenity—I sometimes think it may be given to our time to express the emotion of movement.

<div align="center">Augustus Vincent Tack, 1922</div>

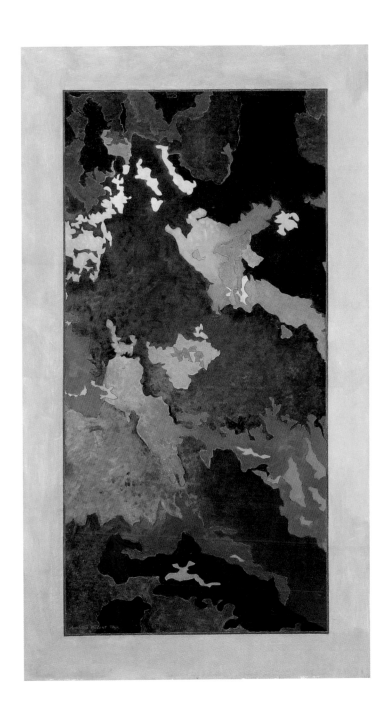

MARK TOBEY

b.1890, Centerville, Wisconsin. d.1976, Basel, Switzerland

After the Imprint, 1961

Gouache on illustration board. 39⅛ in.×27⅛ in. Acquired 1962

We hear some artists speak today of the *act of painting*, but a State of Mind is the first preparation and from this the action proceeds. Peace of Mind is another ideal, perhaps the ideal state to be sought for in the painting and certainly preparatory to the act.

Mark Tobey, 1958

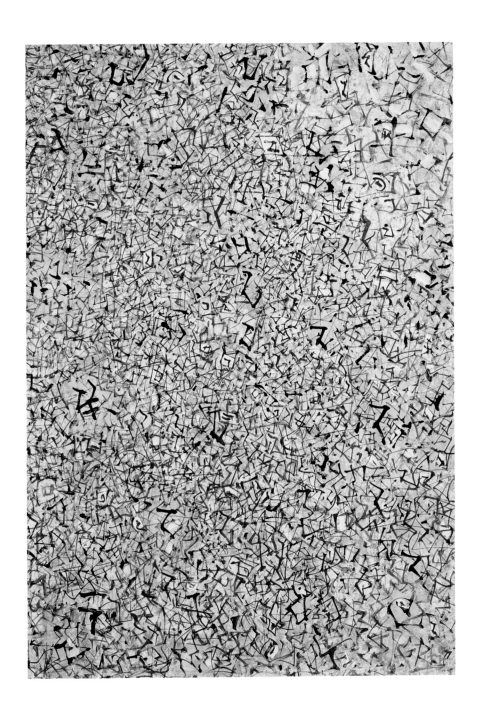

BRADLEY WALKER TOMLIN

b.1899, Syracuse, New York. d.1953, New York, New York

No. 9, 1952

Oil on canvas. 84 in.×79 in. Acquired 1957

He was one of the most intelligent and literate of the New York group, and didn't go in for the manifesto-rhapsodies that cluttered up the talk of some of the others. . . . Tomlin was one of the few, I think, who understood that you don't contact the unconscious mind by refusing to use the conscious one; also that the work of the unconscious is truly conscious, has nothing to do with will or with programmatic invitation. His paintings seemed to me to be in some way analogous to those states in which rigorous thought and ethical demand, and a field of feelings combine into a momentary harmony and are lit or lifted, by a suffusion of energy. . . . There was ease and lightness in his work.

George Dennison, 1970

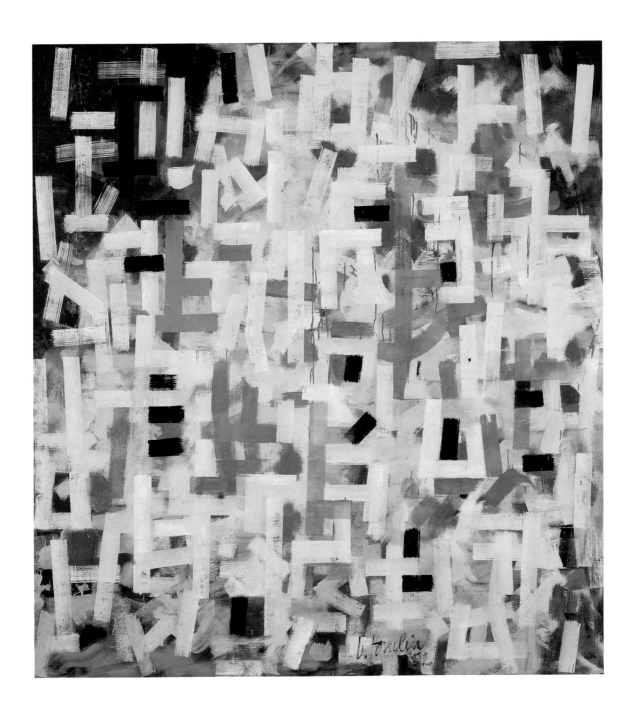

JOHN HENRY TWACHTMAN

b.1853, Cincinnati, Ohio. d.1902, Gloucester, Massachusetts

Summer, late 1890s

Oil on canvas. 30 in.×53 in. Acquired 1919

Twachtman's art is luminism carried to the heights of spiritual expression. No technical innovations are used and no stylized conventions. And yet Twachtman was essentially modern in mind and he is certainly a connecting link between the present and the past in American painting. In the beautiful landscape entitled *Summer* we are far from the mere transcription of fact and even of evanescent appearence of a definite place at a precise hour of the day. What we see and feel is a muted movement of jewelled light over a solid earth. We are caught up with the processional clouds in a universal rhythm which moves with majesty across the canvas and beyond its borders into the universe of space. This is the essence of summer and its warm, vibrant, earth-laden and grass-scented winds.

Duncan Phillips, 1931

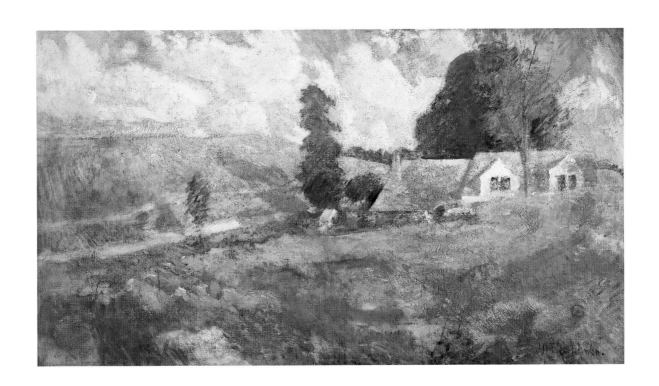

ÉDOUARD VUILLARD

b.1868, Cuiseaux, Saône-et-Loire, France. d.1940, La Baule, Brittany, France

The Newspaper, 1896–98

Oil on cardboard. 13½ in.×21¾ in. Acquired 1929

You feel that he has unresting passion for art. His way of life has a dignity that commands respect. He lives with his mother, keeps well away from the cliques, and does his work in their small family apartment. . . . His deftly noted interiors have great charm. He has a marvellous understanding of the timbre of things. They're the work of a fine painter—those many-coloured panels, predominantly dark in key, but always with an explosion of bright colour that somewhere re-establishes the harmony of the whole picture.

Paul Signac, 1898

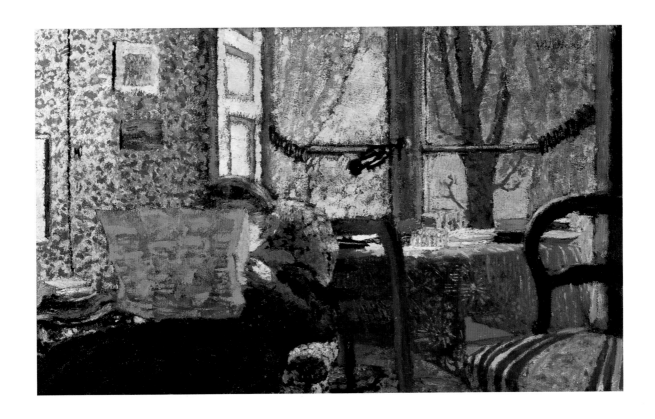

ÉDOUARD VUILLARD

b.1868, Cuiseaux, Saône-et-Loire, France. d.1940, La Baule, Brittany, France

Woman Sweeping, 1899 or 1900

Oil on cardboard. 17⅜ in.×18⅜ in. Acquired 1939

He was receptive to impressions, constantly, unremittingly, almost tirelessly. Thus there arose a state of intense emotion, a kind of love, for things as well as for human beings, which was to possess him ever after. Wherever he was, his sensitivity and his intelligence were at work, fastening on everything, constantly and feverishly. . . . Among familiar objects, before a jug in which anemones were unfolding, or in the country, in ecstasy before a convolvulus or the vanishing lines of a hill, this twofold activity was as unceasing as a bee's.

Thadée Natanson, 1948

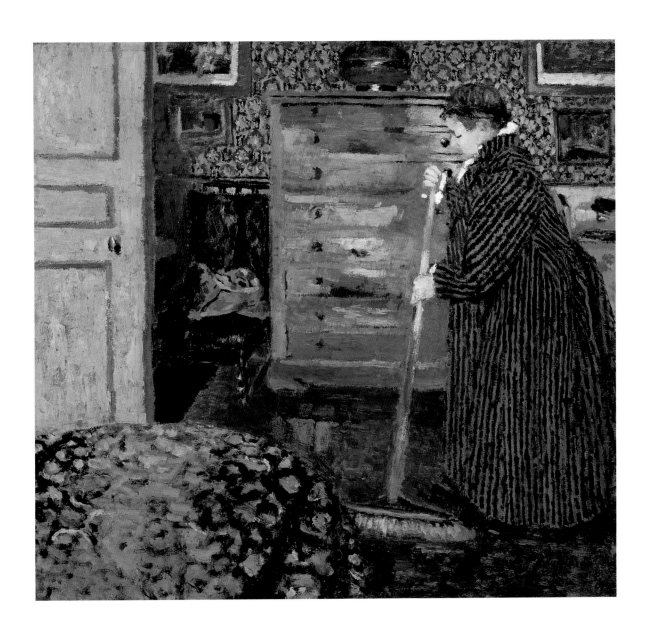

JULIAN ALDEN WEIR

b. 1852, West Point, New York. d. 1919, New York, New York

Roses, 1883–84

Oil on canvas. 35½ in. × 24¾ in. Acquired 1920

Collectors are proud today if they have kept the luscious paintings of roses arbi-
trarily relieved against dark backgrounds, which they probably acquired with-
out due appreciation of their historical importance. These things possess so
delicious and unctuous a pigment, so charmingly rendering their subjects
with especial regard to richness of tone and texture, that they would make Weir
sure of a reputation as a painter's painter even if he had not gone on to greater
achievements.

Duncan Phillips, 1920

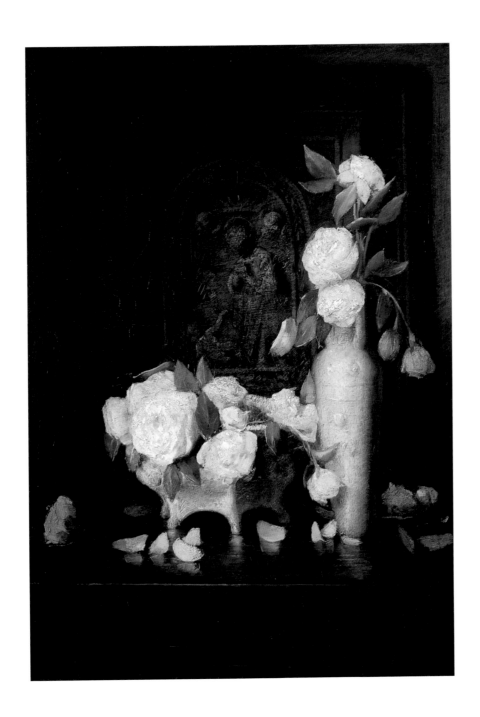

JAMES ABBOTT MCNEILL WHISTLER

b. 1834, Lowell, Massachusetts. d. 1903, London, England

Miss Lillian Woakes, 1890–91

Oil on canvas. 21 in.×14 in. Acquired 1920

A picture is finished when all trace of the means used to bring about the end has disappeared. . . . To say of a picture, as is often said in its praise, that it shows great and earnest labour, is to say that it is incomplete and unfit for view. . . . Industry in art is a necessity—not a virtue—and any evidence of the same, in the production, is a blemish, not a quality; a proof not of achievement, but of absolutely insufficient work, for work alone will efface the footsteps of work.

James Abbott McNeill Whistler, 1893

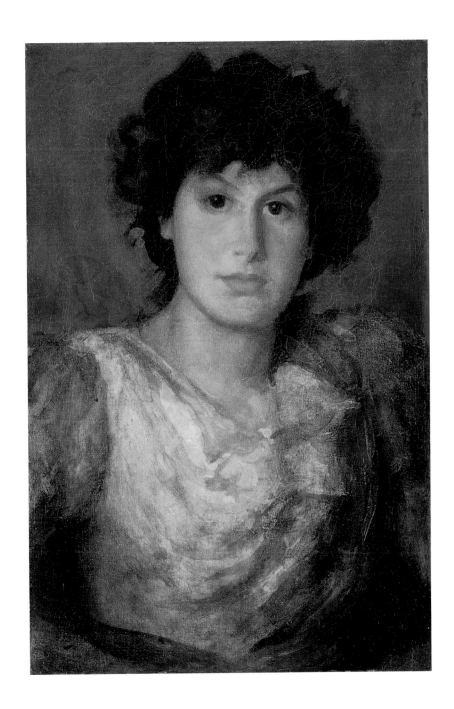

CHRONOLOGY

1886 *June 26.* Duncan Clinch Phillips, Jr., the second son of Major Duncan Clinch Phillips and Eliza Irwin Laughlin, is born in Pittsburgh, Pennsylvania. His older brother, James Laughlin, was born in 1884. Major Phillips had served as a volunteer in the Civil War, becoming a manufacturer of window glass in Pittsburgh. Eliza's father, James Laughlin, was a banker and co-founder of the Jones and Laughlin Steel Co.

1895 Mrs. James Laughlin dies. Major and Mrs. Phillips spend the winter of 1895–96 in Washington and decide they prefer the climate to Pittsburgh's.

1897 Major Phillips buys property at 21st and Q Streets, Northwest, and builds a house designed by Hornblower and Marshall.

1904 Duncan and Jim are enrolled at Yale University.

1905 Duncan publishes his first article, "At the Opposite Ends of Art" (*The Yale Literary Magazine* 70, June 1905).

1907 Duncan is elected an editor of *The Yale Literary Magazine*, serving 1907–8. He publishes an article, "The Need of Art at Yale," in the June issue.

Hornblower and Marshall submit plans for the addition of a paneled library (now called the Music Room).

1908 Duncan and Jim graduate from Yale University.

1911 *Summer.* Duncan takes a trip to Europe; in Paris he visits the Louvre, the apartment of the great art dealer, Paul Durand-Ruel, and the Musée du Luxembourg.

1913 In December Duncan Phillips publishes a stinging review of the Armory Show, "Revolutions and Reactions in Painting" (*The International Studio* 51, December 1913), calling it "stupefying in its vulgarity."

1914 Jim and Duncan Phillips are currently living in New York. While Jim is the assistant director of the National Civic Federation, Duncan publishes his first book, *The Enchantment of Art* (New York: John Lane Company, 1914), a series of 17 essays, including his 1913 review of the Armory Show. This essay is again reprinted in the 1927 edition of this book, but substantially changed and amended by a new foreword to reflect his more mature views:

Many of the ideas I was then eager to oppose I am now less eager to uphold . . . To the charge of inconsistency I plead guilty, but it does not trouble my conscience. Consistency from youth to middle age is at best a stiff-necked virtue.

1916 *January 6.* Jim writes to his father about both brothers' enthusiasm for paintings and for collecting; he requests a yearly stipend for art purchases. A fund is duly established, and many of the early acquisitions are made by Jim as well as Duncan.

1917 *September 13.* Major Phillips dies suddenly.

Upon the United States' entry into World War I, Duncan volunteers for service, is rejected for health reasons, and decides to join the Division of Pictorial Publicity, charged with inspiring artists to produce images of war. Slides are made, lectures prepared, and plans laid for the Allied War Salon (December 9–24, 1918), an exhibition held at the American Art Galleries, New York.

1918 *October 21*. James Laughlin Phillips dies of Spanish flu in Washington, D.C.—13 months after his father's death.

Duncan and his mother decide to found the Phillips Memorial Art Gallery, and Duncan begins to build a collection with this view. He makes numerous purchases so that, by June 1921, he publishes a checklist of the collection comprising some 230 titles. A handwritten note lists his "15 best purchases of 1918–19," including one work by Twachtman, two each by Monet and Weir, and Chardin's *A Bowl of Plums* (c. 1728).

1920 *March 3–31*. The Corcoran Gallery of Art shows an "Exhibition of Selected Paintings from the Collections of Mrs. D. C. Phillips and Mr. Duncan Phillips of Washington." On view are 62 works.

May. McKim, Mead & White design a second skylit story over the north wing of 1600 21st Street. This addition becomes the Main Gallery once the museum opens.

July 23. The Phillips Memorial Art Gallery is incorporated. Phillips will write about his aims for the museum: *The idea to which this unique collection is consecrated is that of a dual function and purpose: the concept of a small intimate museum of the world's best art combined with an experiment station where living and constantly developing artists can show the results of their research and their aesthetic adventures.*

November 20–December 20. Duncan Phillips lends 43 paintings to The Century Club in New York. The exhibition is called "Selected Paintings from the Phillips Memorial Art Gallery." Shown are works by Monet, Daumier, Ryder, Twachtman, and Weir.

Marjorie Acker, a young artist, visits the exhibition and is deeply impressed by Duncan Phillips. Born in Bourbon, Indiana, on October 25, 1894, Marjorie began her studies in 1914 at The Art Students League, New York. Her first exhibition was held at Kraushaar Galleries, New York, in 1923.

1921 *May*. Marjorie Acker and the Gifford Beals visit the Phillipses' house in Washington and see the Main Gallery and North Library hung with paintings.

October 8. Duncan Phillips and Marjorie Acker are married in Ossining, New York.

Late in the fall the Gallery quietly opens to the public; it is the beginning of the first museum of modern art in America.

Phillips is working on the introductions to the first two books of a projected series entitled Phillips Collection Publications. At the same time he elaborates on his idea for an annual publication, *The Herald of Art*.

1922 *January 3*. Duncan Phillips writes letters to the three leading Washington newspapers announcing the new season. The Gallery is named the Phillips Memorial Art Gallery for only about one year before being renamed the Phillips Memorial Gallery. In October 1948 it becomes formally known as The Phillips Gallery, finally to be called The Phillips Collection in July 1961.

Phillips Collection Publications Number One and Number Two appear in rapid succession. The first is a collection of essays, *Julian Alden Weir* (New York: E. P. Dutton & Company, 1922), and the other a work entitled *Honoré Daumier, Appreciations of His Life and Works* (New York: E. P. Dutton & Company, 1922).

February 15. William Mitchell Kendall, of McKim, Mead & White, and head of the Gallery's committee on architecture, submits the committee's recommendations for a new museum to be built in Washington. The museum is never built; instead, the family later moves to a new residence, leaving the existing building for the collection.

July 10. Daughter Mary Marjorie is born in New York.

November. In a press release sent to *The Evening Star*, Phillips announces the fall exhibition of the Phillips Memorial Art Gallery—31 works highlighting major new acquisitions.

1923 *June 6*. Duncan and Marjorie Phillips sail from New York for a two-month stay in Europe. During lunch at the Joseph Durand-Ruels, they see Renoir's *Luncheon of the*

Boating Party. They decide to buy the painting, which is sent to the United States later that year.

December. The fall season of 1923 opens with a changed gallery hanging of the permanent collection, including the great Renoir.

1924 *March 26–April 26.* The Phillips Memorial Gallery presents the "Exhibition of Recent Decorative Paintings by Augustus Vincent Tack." The 16 works represent the first museum showing for this artist, who was a fellow member of The Century Club and Phillips's friend from his days in New York.

Duncan Phillips sees Pierre Bonnard's painting, *Woman with Dog* (1922), at the Carnegie International Exhibition in Pittsburgh and purchases it the following year—the first of 16 paintings by Bonnard to enter the collection.

October 20. Son Laughlin Phillips is born in Washington, D.C. A publisher and former Foreign Service officer, Laughlin Phillips was The Phillips Collection's director from 1972 to 1992.

1925 In early January Phillips inaugurates a series of small one-artist exhibitions in the newly opened Little Gallery. Opening with 10 recent works by Marjorie Phillips, the gallery is henceforth used to focus on the work of American artists. The Main Gallery, meanwhile, continues to feature newly acquired works by European and American masters.

February 15. *The Sunday Star* announces that the Phillips Memorial Gallery has purchased *The Uprising* (circa 1848) by Honoré Daumier.

1926 *January 11–February 7.* An exhibition of work by Arthur Dove is held at Alfred Stieglitz's Intimate Gallery in New York. Duncan Phillips buys his first two paintings by Dove, *Golden Storm* (1925) and *Waterfall* (1925), and includes them in his own "Exhibition of Paintings by Eleven Americans and an Important Work by Odilon Redon," opening in February. He will eventually purchase more than 48 works by Dove.

Duncan Phillips's book, *A Collection in the Making* (New York: E. Weyhe with the Phillips Memorial Gallery, 1926) is published.

September. The Phillipses meet Bonnard, who visits the Gallery while in the United States as a juror for the Carnegie International Exhibition.

1927 *February 5 through April.* The museum presents the first of five Tri-Unit Exhibitions (two installations follow in 1928–29, with two final exhibitions in 1929–30).

On January 15 Phillips had written to Alfred Barr (soon to be the first director of The Museum of Modern Art) about showing several Marins: "In February and March I will give Washington a bracing shock in the work of this stimulating creator, with his incisive brain, his flashing eye, his startling intuition and magic with his medium."

1928 *March 6–31.* "Exhibition of Paintings by John Graham."

November. The Art Gallery of Toronto presents "An Exhibition of Paintings Lent by the Phillips Memorial Gallery, Washington: French Paintings from Daumier to Derain and Contemporary American Paintings."

1929 *February 2.* An exhibition of watercolors by John Marin is installed in the Little Gallery. In the Lower Gallery, "A Retrospective Exhibition of Paintings by Arthur B. Davies."

October 25. Duncan Phillips is elected to the board of trustees of The Museum of Modern Art, New York.

C. Law Watkins, an artist, former Yale classmate, and friend of Duncan Phillips's, becomes Associate Director in Charge of Education. He gives free lessons in painting at the Gallery, and the classes grow from a handful of students in 1929 to an enrollment of approximately 200 pupils by 1931.

November. Art and Understanding, the first of a projected series of journals, is published by the Phillips Memorial Gallery.

December. "An Exhibition of Recent Paintings by Karl Knaths." Phillips bought his first painting by Knaths in

1926, eventually accumulating the largest museum collection of works by the artist. The relationship of artist and patron soon grows into a lasting friendship, and Knaths joins the faculty of the art school as a guest instructor in 1938.

By 1930, Duncan Phillips begins to refer to the Phillips Memorial Gallery as "a museum of modern art and its sources."

1930 With Stieglitz acting as intermediary, Duncan Phillips begins paying Arthur Dove a monthly stipend in return for first choice of paintings from the annual Dove exhibitions organized by Stieglitz. Although he carries on an active correspondence with Dove and remains his most faithful supporter, Phillips meets the artist only once, in the spring of 1936.

March. The second volume of *Art and Understanding* is published.

May. J. B. Neumann, a New York gallery owner, sends three paintings by Paul Klee on approval. Phillips purchases *Tree Nursery*, the first of 13 paintings by Klee to enter the collection.

Fall. The Phillips family moves to a new house at 2101 Foxhall Road. "Dunmarlin" (for Duncan, Marjorie, and Laughlin) was designed by the architect Nathan Wyeth. Phillips and C. Law Watkins work on the conversion of the former residence into galleries, offices, and storage space.

September 26. Henri Matisse, a member of the European jury of the Carnegie International Exhibition, visits the Phillips Memorial Gallery.

October 5, 1930–January 25, 1931. To celebrate the new season, Phillips installs eight exhibitions and gallery hangings. In subsequent seasons he continues his practice of interpreting the works from his collection through changing gallery hangings.

1931 *March 20.* Duncan Phillips delivers the Trowbridge Lecture, "The Artist Sees Differently," at Yale University. The concepts developed in this popular lecture form the nucleus of the book *The Artist Sees Differently: Essays Based Upon the Philosophy of the Collection in the Making* (New York: E. Weyhe, 1931).

1932 *February.* "Daumier and Ryder" and "American and European Abstractions" open at the Phillips Memorial Gallery. Included are four paintings by Arthur Dove, two each by Georges Braque and Pablo Picasso, and one painting each by Juan Gris and Karl Knaths.

The Phillipses, accompanied by their son Laughlin, embark on the first of three "Giorgione trips" as part of Phillips's research on the artist, which eventually leads to a publication in 1937. In June Phillips writes his first letter to Bernard Berenson, a correspondence that lasts for several years and deals with issues of attribution and interpretation of works by Giorgione.

In a letter dated October 19, Phillips declines the request of the Yale University Art Gallery to give the entire Phillips Collection to Yale.

Fall. The Phillips Gallery Art School closes through the summer of 1933 due to the Depression; the Gallery is open only Saturdays from 11 a.m. to 6 p.m., not to resume its full schedule until October 1933.

1932–33 Duncan Phillips is chairman of the Regional Committee No. 4, Public Works of Art Project. Artists are commissioned to paint murals and easel paintings representing "The American Scene."

1933 *October 14–November 15.* Studio House, a combination sales gallery and art school established by C. Law Watkins, opens its doors at 1614 21st Street, Northwest, with an "Opening Exhibition of Recent American Painting." Art classes previously conducted at the museum move to Studio House and are expanded to life classes, anatomy classes, and advanced courses in painting. Conferences on comparative criticism are conducted at the Gallery under the guidance of Duncan Phillips.

November 5, 1933–February 15, 1934. The exhibition "Freshness of Vision in Painting" features a rehanging of all galleries. Included are: "Pictures of People," an exhibition in-

stalled in three galleries; works by Louis Eilshemius and Charles Burchfield hung in two separate galleries; a theme exhibition, "Classic and Romantic"; and other paintings gathered under the subject "Modern Idioms—Lyrical and Impersonal."

1934 The first annual "Exhibition of Paintings and Drawings by Students of the Phillips Memorial Art School and of Artists Associated with Studio House" is held at Studio House. These exhibitions continue until 1938.

December 29. Gertrude Stein delivers her lecture "Pictures" at the Phillips Memorial Gallery.

1935 *November.* Phillips delivers an address on the Public Works of Art Project, pleading for extension of the program and continued funding.

1937 Beginning with the 1937/38 season, the exhibition program at the Phillips Memorial Gallery becomes very active. Eighteen exhibitions are installed in all galleries and special drawing shows are presented in The Print Rooms.

March 23–April 18. The Gallery presents a "Retrospective Exhibition of Works in Various Media by Arthur G. Dove." This exhibition of 57 works is Dove's first major retrospective at the Gallery—the only during the artist's lifetime.

Duncan Phillips publishes *The Leadership of Giorgione* (Washington, D.C.: American Federation of Arts, 1937).

1938 *March 10.* The Print Rooms feature a small exhibition from the permanent collection, supplemented by loans, "An Exhibition of Watercolors and Oils by Paul Klee."

Fall. Studio House closes permanently. The Phillips Gallery Art School moves to the top floor of the Phillips Memorial Gallery. The staff remains the same, but the exhibition program is discontinued.

1939 *January 1–20.* "Toulouse-Lautrec: Exhibition of Drawings, Lithographs, Posters" is held in The Print Rooms.

By 1939, the exhibition program has increased to 25 separate exhibitions and gallery hangings, among them 19 paintings by Édouard Vuillard and portraits by C. Law Watkins.

1940 Duncan Phillips becomes a trustee and member of the acquisition committee of the National Gallery of Art.

April 7–May 5. C. Law Watkins develops his first educational exhibition, "Emotional Design in Painting," presenting 72 works grouped under 28 motifs and design concepts. Works by old masters on loan from museums nationwide are hung with contemporary works in a didactic sequence, exploring the expressive function of diagonals, organic forms, motion, and shape.

December 15. "Georges Rouault: Retrospective Loan Exhibition" opens at the Gallery.

1941 The Museum of Modern Art, New York, receives a painting, Arthur Dove's *Willows* (1940), as a gift from Duncan Phillips.

June. Phillips buys a painting by Honoré Daumier as a gift for the National Gallery of Art.

1942 From about January to September 26, 1944, thirty-three works from the Phillips Memorial Gallery go to the Colorado Springs Fine Arts Center for safe exhibition and storage during the period of possible air raids. Other works go to the William Rockhill Nelson Gallery of Art in Kansas City, where they are exhibited for approximately the same time.

February 14–March 3. The Phillips Memorial Gallery is the first museum to exhibit Jacob Lawrence's series "The Migration of the Negro" in an exhibition entitled "And the Migrants Kept Coming." At the end of this show, Duncan Phillips purchases the 30 odd-numbered panels. The even-numbered ones enter the collection of The Museum of Modern Art, which from 1942 to 1944 circulates the entire series on a nationwide tour.

Spring. Phillips purchases his first two works by Morris Graves, eventually developing a Graves Unit.

"Paul Klee: A Memorial Exhibition" opens in June.

1943 During the spring and fall seasons the gallery presents 29 exhibitions, among them numerous one-artist exhibitions showing the work of Milton Avery, Augustus Vincent Tack, and Arthur Dove as well as several exhibitions of drawings, photographs, and students' work.

August 1–September 30. "John Marin: A Retrospective Loan Exhibition of Paintings," organized by the Phillips Memorial Gallery, features 20 works.

1945 *January 14–February 26.* The exhibition "Eugène Delacroix: A Loan Exhibition" presents 13 works from Wildenstein Galleries, New York.

October 21–November 17. "A Loan Exhibition of Fifty-Two Drawings for Ariosto's 'Orlando Furioso' by Fragonard" is shown in The Print Rooms. Phillips purchases two drawings, No. 93 and No. 110, for the collection.

1946 *November 3–24.* The Phillips Memorial Gallery shows "Pioneers of Modern Art in America," a traveling exhibition of 64 works, circulated by the American Federation of Arts.

November 22. Arthur Dove dies in Huntington, Long Island. In October he had written his last letter to Duncan and Marjorie Phillips:

After fighting for an idea all your life I realize that your backing has saved it for me and I meant to thank you with all my heart and soul for what you have done.

1947 *March 30–April 30.* "Loan Exhibition of Drawings and Pastels by Edgar Degas," an exhibition of 36 works, is shown in The Print Rooms.

April 18–September 22. "A Retrospective Exhibition of Paintings by Arthur G. Dove." In the course of the year Duncan buys three watercolors and two paintings by Dove from The Downtown Gallery, increasing the Dove Unit to more than 40 works.

1948 *October 17–November 7.* "Sixty Drawings by Matisse," a selection from a large drawing exhibition held in Philadelphia, is shown in The Print Rooms and subsequently circulated by the American Federation of Arts.

December 7, 1948–January 17, 1949. "Oskar Kokoschka: A Retrospective Exhibition," organized and circulated by the Institute of Contemporary Art, Boston, is held at the Gallery. On view are 126 works. The artist visits Washington on January 11 and lectures on his work.

1949 *March 24–May 2.* "Paintings, Drawings, and Prints by Paul Klee from the Klee Foundation, Berne, Switzerland, with Additions from American Collections." The exhibition, comprising 202 works, includes a major loan from the foundation's holdings, never before exhibited in the United States. Five paintings from The Phillips Gallery are lent to this exhibition.

May 8–June 9. A loan exhibition of 31 works, "Paintings by Grandma Moses," is shown in The Print Rooms. Duncan Phillips purchases the painting *Hoosick Falls in Winter* (1944).

Phillips writes an article, "Pierre Bonnard" (*The Kenyon Review* II, Autumn 1949).

November 6–29. Alfred Stieglitz's *Equivalents* series is exhibited in The Print Rooms.

1950 *May 28–June 20.* A traveling exhibition, "Edvard Munch," organized by the Institute of Contemporary Art, Boston, opens at The Phillips Gallery. Included are 171 paintings.

June 25–September 16. Phillips installs nine works by Augustus Vincent Tack in the Main Gallery for the "Memorial Exhibition: Abstractions by A. V. Tack." The artist had died on June 21, 1949.

1952 *March 29.* Katherine S. Dreier dies, leaving part of her private collection to be dispersed by her executors. On May 7, Marcel Duchamp announces his visit to Washington, and upon arriving, he informs Phillips of the executors' decision to make a major bequest to The Phillips Gallery. Phillips chooses 17 works, including major paintings by Braque, Klee, Mondrian, and Kandinsky. At Phillips's suggestion, 14 works from the Dreier Bequest are sent to the fledgling Watkins Gallery at the American University.

1952 The first comprehensive catalogue of the collection is published, *The Phillips Collection: A Museum of Modern Art and Its Sources* (New York and London: Thames and Hudson, 1952).

November. Duncan Phillips gives a painting by Edgar Degas, *Ballet Rehearsal* (c. 1885), to the Yale University Art Gallery on the occasion of the laying of the cornerstone for the new gallery.

1956 *May 13–June 4.* "Paintings by Nicolas de Staël," an exhibition circulated by the American Federation of Arts, is shown at the Gallery. In 1950 Phillips had bought *North* (1949), the first work by this artist to be acquired by an American museum. During the early 1950s, Phillips had established a de Staël unit, a representative block of works that offers a survey of the artist's stylistic development.

1957 *January 6–February 26.* A small exhibition entitled "Paintings by Tomlin, Rothko, Okada," is held in The Print Rooms, the first showing of Rothko's work at the Gallery.

1959 *April 24.* As part of its 50th anniversary, the American Federation of Arts makes awards for outstanding contribution to art and artists in America. Honorees are Duncan Phillips, Robert Woods Bliss, Alfred Barr, and Paul J. Sachs.

1960 *November 5.* The new wing of the museum opens to the public. The Braque Unit is displayed downstairs, and a small room is designated to display the three paintings by Mark Rothko now in the collection. A fourth painting is added to the Rothko Room in 1964. Marjorie Phillips recalls in her book that "Duncan derived untold pleasure from this room."

1961 Duncan Phillips continues his practice of introducing the work of contemporary artists in small, one-artist exhibitions in The Print Rooms.

March 12–April 12. "Vieira da Silva," includes 25 works, and *Easels* (1961) is purchased for the collection.

May 19–June 26. A loan exhibition, "Richard Diebenkorn," also shown in The Print Rooms, includes 18 works.

In July of this year the museum's name is officially changed to The Phillips Collection.

1962 *January 28–February 28.* "Paintings by Josef Albers," a loan exhibition of 20 works, is installed in The Print Rooms.

March 11–April 30. With the showing of "David Smith: An Exhibition of Abstract Sculpture: A Survey of the Artist's Development in the Last Two Decades," organized by The Museum of Modern Art, The Phillips Collection begins a series of large, important sculpture exhibitions.

May 6–July 1. The entire museum is given over to an exhibition of the work of Mark Tobey. Organized by The Phillips Collection, the loan exhibition presents 45 works dating from 1935 to 1961.

1963 *February 7–May 18.* The Phillips Collection presents the exhibition "Giacometti," 37 sculptures. *Monumental Head* (1960) is purchased for the collection.

1964 For the spring and fall seasons, the museum embarks on an active program of exhibitions. As has been his practice since the early days of the Gallery, Phillips purchases one or more works from most exhibitions while, at the same time, adding the works of younger artists to his "Encouragement Collection."

January 12–February 24. "Seymour Lipton."

March 14–April 16. "Manessier."

October 3–November 17. "The Cubist Period of Jacques Lipchitz."

November 14–December 27. "Étienne Hajdu."

1966 *April 9–May 30.* The Phillips Collection installs an exhibition of 36 works, "Paintings by Arthur G. Dove from the Collection."

May 9. Shortly after having supervised the installation of the Dove exhibition, Duncan Phillips falls ill and dies at his home in Washington, D.C.

ERIKA PASSANTINO and SARAH MARTIN

SOURCE CITATIONS

Page 20: Mark Rothko, "Commemorative Essay," delivered at the New York Society for Ethical Culture, Jan. 7, 1965, reprinted in Adelyn D. Breeskin, *Milton Avery* (Washington: National Collection of Fine Arts, Smithsonian Institution, 1969). **22:** Quoted in Allen S. Weller, *Contemporary American Painting* (Urbana, Ill.: College of Fine and Applied Arts, Univ. of Illinois, 1951). **24:** From an interview with Miriam Gross, "Bringing Home Bacon," *Observer*, Nov. 30, 1980, reprinted in Hugh Davies and Sally Yard, *Francis Bacon* (New York: Abbeville, 1986). **26:** Pierre Bonnard to Ingrid Rybeck in *Konstrevy* 13, no. 4, 1937. **28:** Pierre Bonnard to Henri Matisse, late Feb.–early Mar. 1940, in *Bonnard/Matisse: Letters Between Friends*, introduction and notes by Antoine Terrasse (New York, 1992). **30:** Quoted in Karen Wilkin, *Georges Braque* (New York: Abbeville, 1991). **32:** Quoted in Douglas Cooper, *Braque: The Great Years* (Chicago: Art Institute, 1972). **34:** Aug. 17, 1914, from *Charles Burchfield's Journals: The Poetry of Place*, edited by J. Benjamin Townsend (Albany: SUNY, 1993). **36:** Rainer Maria Rilke to his wife, Oct. 23, 1907, in Rainer Maria Rilke, *Briefe über Cézanne*, ed. Clara Rilke (Frankfurt: Insel, 1952), quoted in Françoise Cachin et al., *Cézanne* (Philadelphia: Philadelphia Museum of Art, 1995–96). **38:** Paul Cézanne, letter to Émile Bernard, May 1904, quoted in Hershel B. Chipp, *Theories of Modern Art* (Berkeley: Univ. of California, 1968). **40:** Roger Fry, *Cézanne: A Study of His Development*, 1927 (reprinted New York, 1958). **42:** Paraphrased by R—N. (Monsieur Robin) in Michaud's *Biographie Universelle ancienne et moderne*, VIII (Paris: Madame C. Desplaces, 1813). **44a:** Quoted in Marietta Minnigerode Andrews, *Memoirs of a Poor Relation* (New York: Dutton, 1929), reprinted in D. Scott Atkinson and Nicolai Cikovsky, Jr., *William Merritt Chase: Summers at Shinnecock 1891–1902* (Washington, D.C.: National Gallery of Art, 1987). **44b:** Quoted in Frances Lauderbach, "Notes from Talks by William Merritt Chase: Summer Class, Carmel-by-the-Sea, California," *The American Magazine of Art* 8 (Sept. 1917). **46:** Quoted by Théophile Silvestre, *Histoire des artiste vivants, français et étrangers: Études d'après nature* (Paris, 1853), reprinted in *Corot* (New York: Metropolitan Museum of Art). **48:** Gustave Courbet to Victor Hugo, quoted in *Courbet* (New York: Wildenstein, 1948). **50:** Duncan Phillips, "The Arts in Wartime," *Art News* (Aug.–Sept. 1942). **52:** *Charles Baudelaire, Selected Writings on Art and Artists*, translated by P.E. Charvet (Cambridge and New York: Cambridge Univ., 1981). **54:** Stuart Davis to Edith Halpert, Aug. 11, 1927, Halpert Papers, reprinted in John R. Lane, *Stuart Davis: Art and Art Theory* (New York: Brooklyn Museum, 1978). **56:** Quoted in H. H. Arnason, *Stuart Davis* (Minneapolis: Walker Art Center, 1957), reprinted in John R. Lane, *Stuart Davis: Art and Art Theory*. **58:** Journal entry, Feb. 12, 1877, in *Journal Goncourt 1956*, II (translation McMullen 1984), quoted in Jean Sutherland Boggs, et al., *Degas* (New York: Metropolitan Museum of Art, 1988). **60:** Quoted in George Moore, *Impressions and Opinions* (New York: B. Blom, 1972). **62:** Duncan Phillips, "The Phillips Gallery," *Arts* (Apr. 1956). **64:** Quoted in Hershel B. Chipp, *Theories of Modern Art* (Berkeley: Univ. of California, 1968). **66:** *The Journal of Eugène Delacroix*, 1854, quoted in Robert Goldwater and Marco Treves, eds., *Artists on Art* (New York: Pantheon, 1972). **68:** Larsen interview, quoted in Jane Livingston, *The Art of Richard Diebenkorn* (New York: Whitney Museum of Art with Univ. of California, 1997). **70:** From "Notes by Arthur Dove," statement in exhibition catalog, The Intimate Gallery, 1929, quoted in Barbara Haskell, *Arthur Dove* (San Francisco: San Francisco Museum of Art, 1974). **72:** Arthur Dove, "A Way to Look at Things," in Frederick S. Wight, *Arthur G. Dove* (Berkeley: Univ. of California, 1958), reprinted from the 1925 exhibition catalogue *Seven Americans*. **74:** Quoted in an essay by Lloyd Goodrich in *Thomas Eakins: A Retrospective Exhibition* (Washington, D.C.: National Gallery of Art, Art Institute of Chicago, and Philadelphia Museum of Art, 1961). **76:** Statement by the artist in a published letter, reprinted in *The New American Painting* (New York: Museum of Modern Art, 1959). **78:** Lee Gatch to Duncan Phillips, reprinted in Perry T. Rathbone, *Lee Gatch* (New York: American Federation of Arts, 1960). **80:** Paul Gauguin to Emile Schuffenecker, Aug. 1888, quoted in John Rewald, *Post-Impressionism from van Gogh to Gauguin*, 3d revised edition (New York: Museum of Modern Art, 1978). **82:** Guy Pène du Bois, *William J. Glackens* (New York: Whitney Museum of American Art, 1931). **84a & b:** Letter to Theo van Gogh, Arles, 1888, quoted in Robert Goldwater and Marco Treves, eds., *Artists on Art* (New York: Pantheon, 1972). **86:** Letter to Theo van Gogh, Dec. 7, 1889, reproduced in *The Complete Letters of Vincent van Gogh* (Boston: New York Graphic Society, n.d.). **88:** Caption in Sidney Janis, *Abstract and Surrealist Art in America* (San Francisco: San Francisco Museum of Modern Art, 1944), quoted in *The Pictographs of Adolph Gottlieb*, organized by Sanford Hirsch (New York: Hudson Hills, 1994). **90:** Duncan Phillips, "The Phillips Gallery," *Arts* (Apr. 1956). **92:** Quoted in Ray Kass, *Morris Graves: Vision of the Inner Eye* (New York: Braziller, 1983). **94:** Duncan Phillips, *A Collection in the Making* (New York: Weyhe with Phillips Memorial Gallery, 1926). **96a:** From James Thrall Soby, *Juan Gris* (New York: Museum of Modern Art, 1958). **96b:** Quoted in Mark Rosenthal, *Juan Gris* (Berkeley: Univ. of California, 1983). **98:** Morton Feldman, "After Modernism," *Art in America* (Nov.–Dec. 1971). **100a & b:** Quoted in Patricia McDonnell, *Hartley: American Modern* (Seattle and London: Univ. of Washington, 1997). **102:** Childe Hassam Correspondence, Papers of the American Academy of Arts and Letters, Archives of American Art, Smithsonian Institution, reprinted in Donelson F. Hoopes, *Childe Hassam* (New York: Watson-Guptil, 1979). **104:** Quoted in George W. Sheldon, *Hours with Art and Artists* (New York: Garland, 1978; orig. pub. 1882). **106a:** From an interview with Aline Saarinen, "Sunday Show," NBC Television, 1964, transcript. **106b:** Edward Hopper to Charles Sawyer, Oct. 29, 1939. **108:** Quoted in John Morse, "Interview with Edward Hopper," *Art in America* 48 (Spring 1960). **110:** Quoted in Walter Pach, *Ingres* (New York, 1939), reprinted in Robert Goldwater and Marco Treves, eds., *Artists on Art* (New York: Pantheon, 1972). **112:** "A Painter on Painting," *Harper's New Monthly Magazine* 56 (Feb. 1878), quoted in Nicolai Cikovsky, Jr., and Michael Quick, *George Inness* (Los Angeles: Los Angeles County Museum of Art, 1985). **114, 116, 118:** Quoted in Jelena Hahl-Koch, *Kandinsky* (New York: Rizzoli, 1993). **120:** Quoted in Fridolf Johnson, *Rockwell Kent: An Anthology of His Works* (New York: Knopf, 1981). **122:** From a 1924 lecture, "On Modern Art," quoted in *Paul Klee* (New York: Bucholz Gallery, 1948). **124a:** Duncan Phillips and C. Law Watkins, *Function of Color in Painting* (Washington, D.C.: Phillips Memorial Gallery, 1941). **124b:** Letter from Paul Klee to his wife, Lily, Aug. 10, 1927, in *Briefe an die Familie*, ed. Felix Klee (Cologne: Dumont, 1979). **126:** In Paul Moscanyi, *Karl Knaths*, introduction by Duncan Phillips (Washington, D.C.: Phillips Gallery, 1957). **128:** Reprinted in Kokoschka exhibition catalog at the Kunstforum Länderbank, Vienna, June 1991, translated from the German by David Britt. **130:** Quoted in Elizabeth Hutton Turner, ed., *Jacob Lawrence: The Migration Series* (Washington, D.C.: Rappahannock with Phillips Collection, 1993). **132a:** Quoted in James McLaughlin Truitt in "Art-Arid

D.C. Harbors Touted 'New' Painters," *Washington Post*, Dec. 21, 1961; reprinted in E. A. Carmean, Jr., *Morris Louis: Major Themes and Variations* (Washington, D.C.: National Gallery of Art, 1976). **132b:** Clement Greenberg in "Louis and Noland," *Art International* (1960), quoted in Michael Fried, *Morris Louis* (New York: Abrams, n.d.). **134:** Duncan Phillips, *Art and Understanding* (Washington, D.C.: Phillips Memorial Gallery, 1929). **136:** Quoted in Hershel B. Chipp, *Theories of Modern Art* (Berkeley: Univ. of California, 1968). **138:** From the artist's statement for a 1913 exhibition, quoted in Dorothy Norman, ed., *The Selected Writings of John Marin* (New York: Pellegrini and Cudahy, 1949). **140:** From "Notes of a Painter," 1908, in Jack D. Flam, *Matisse on Art* (London: Phaidon, 1973). **142:** From "The Role and Modalities of Colour," 1945, in Jack D. Flam, *Matisse on Art*. **144:** Quoted in Hershel B. Chipp, *Theories of Modern Art* (Berkeley: Univ. of California, 1968). **146:** From a conversation with Joan Mitchell, Jan. 12, 1986, in Yves Michaud, *Joan Mitchell: New Paintings* (New York: Xavier Fourcade, 1986). **148a:** Jean Cocteau, *Modigliani* (London: A. Zwemmer, 1950). **148b:** Amedeo Modigliani to Oscar Ghiglia, c. 1901, published in *Arte*, No. 3 (1930). **150:** Quoted in Hershel B. Chipp, *Theories of Modern Art* (Berkeley: Univ. of California, 1968). **152:** Reprinted in Harry Holtzman and Martin James, *The New Art—The New Life: The Essays of Piet Mondrian* (Boston: G. K. Hall, 1986). **154:** Guy de Maupassant, "La vie d'un paysagist," *Le Gil Blas*, Sept. 28, 1886, reprinted in Couard, *Maupassant: Oeuvres complètes*, vol. II, quoted by John Rewald, *The History of Impressionism*, 4th revised edition (New York: Museum of Modern Art, 1973). **156:** Quoted in *Giorgio Morandi* (London: Arts Council of Great Britain, 1970). **158:** From Paul Valéry, "Au sujet de Berthe Morisot," preface to catalogue of Morisot exhibition at the Orangerie, summer 1941. **160:** From a statement in *The New Decade* (New York: Whitney Museum and Macmillan, 1955), reprinted in Frank O'Hara, *Robert Motherwell* (New York: Museum of Modern Art and Doubleday, 1965). **162:** Quoted in John Summerson, *Ben Nicholson* (West Drayton, England: Penguin, 1948). **164:** Quoted in Diane Waldman, *Kenneth Noland: A Retrospective* (New York: Abrams with Guggenheim, 1977); from Paul Cummings, unpublished interview with Kenneth Noland, tape recorded at the artist's studio Dec. 9 & 21, 1971, on deposit at the Archives of American Art, New York. **166:** Quoted in *New York Sun* (Dec. 5, 1922). **168:** From Georgia O'Keeffe, *Georgia O'Keeffe* (New York: Viking Press, 1976). **170:** From 1913 diary entry, quoted in Betsy Tahlman, *Guy Pène du Bois: Artist About Town* (Washington, D.C.: Corcoran Gallery of Art, 1980). **172:** Marjorie Phillips, *Marjorie Phillips and Her Paintings* (New York: Norton, 1985). **174:** Gustave Coquiot, *Cubistes, futuristes, passéistes* (Paris: Ollendorf, 1914), quoted by Robert J. Boardingham in Marilyn McCully, ed., *Picasso: The Early Years, 1892–1906* (Washington, D.C.: National Gallery of Art, 1997). **176:** Quoted in Hershel B. Chipp, *Theories of Modern Art* (Berkeley: Univ. of California, 1968). **178:** From André Lhote, "Les Arts: Picasso," *La Nouvelle Revue Française* 306 (Mar. 1, 1939), translated from French by P. S. Falla, quoted in Marilyn McCully, ed., *A Picasso Anthology: Documents, Criticism, Reminiscences* (Princeton: Princeton Univ., 1982). **180:** Quoted in Dorothy C. Miller, *Masters of Popular Painting: Modern Primitives of Europe and America* (New York: Museum of Modern Art, 1938), reprinted in Judith Stein, *I Tell My Heart: The Art of Horace Pippin* (Philadelphia: Pennsylvania Academy of Fine Arts, 1994). **182:** Quoted in B. H. Friedman, *Jackson Pollock: Energy Made Visible* (New York: McGraw-Hill, 1972). **184:** Duncan Phillips, *The Enchantment of Art* (New York: John Lane, 1924). **186:** Quoted in Lionello

Venturi, *Les archives de l'impressionisme*, vol. I (Paris, 1939); Ambroise Vollard, *Renoir, an Intimate Record* (New York, 1930), reprinted in Robert Goldwater and Marco Treves, eds., *Artists on Art* (New York: Pantheon, 1972). **188a:** From *The Tiger's Eye* 2 (Dec. 1947). **188b:** From "A Symposium on How to Combine Architecture, Painting, and Sculpture," *Interiors* 10 (May 1951). **190:** Georges Rouault, "Climat pictural," *La Renaissance*, XX, no. 10–12 (Oct. 1937), quoted in Lionello Venturi, *Rouault* (New York: Weyhe, 1942); reprinted in Robert Goldwater and Marco Treves, eds., *Artists on Art* (New York: Pantheon, 1972). **192:** *Art News*, Feb. 15, 1942, quoted in Roger Shattuck et al., *Henri Rousseau* (New York: Museum of Modern Art, 1985). **194:** From "Paragraphs from the Studio of a Recluse," record of interview with Adelaide Louise Samson, *Broadway Magazine* (Sept. 1905). **196:** Marsden Hartley, "Albert P. Ryder," *Adventures in the Arts* (New York: Boni and Liveright, 1921). **198:** Georges Hugnet in Alfred Barr, Jr., ed., *Fantastic Art, Dada, Surrealism* (New York: Museum of Modern Art, 1936 [1937]). **200:** From Teodor de Wyzewa, "Georges Seurat," *L'Art dans les deux mondes* (Apr. 18, 1891), quoted in William Inness Homer, *Seurat and the Science of Painting* (Cambridge, Mass.: M.I.T., 1964). **202:** Quoted in Carol Troyen and Erica E. Hirshler, *Charles Sheeler: Paintings and Drawings* (Boston: Museum of Fine Arts, 1988). **204a:** Walter Sickert, lecture, "Straws from Cumberland Market," 1923–4, quoted in Robert Emmons, *The Life and Opinions of Walter Richard Sickert* (London: Lund Humphries, 1992; orig. pub. 1941). **204b:** Cyril Connolly, "Spring Showings," *Architectural Review* 71 (Apr. 1932). **206:** Alfred Sisley to Adolphe Tavernier, Jan. 1892, quoted in Raymond Cogniat, *Sisley*, translated by Alice Sachs (New York: Crown, 1978). **208a:** John Sloan, *Gist of Art: Principles and Practise Expounded in the Classroom and Studio* (New York: Dover, 1977; orig. pub. 1939). **208b:** From *John Sloan: Retrospective Exhibition* (Andover, Mass.: Addison Gallery of Art, Phillips Academy, 1938). **210a:** From "My Years with Soutine," as told by "Mademoiselle Garde" to Michael Ragon, in *The Selective Eye* (Lausanne: Bernier; New York: Reynal, 1956/57), reprinted in Maurice Tuchman, *Chaim Soutine: 1893–1943* (Los Angeles: Los Angeles County Museum of Art, 1968). **210b:** Chana Orloff, "Mon ami Soutine," *Preuves* (Nov. 1951), reprinted in Maurice Tuchman, *Chaim Soutine: 1893–1943*. **212:** Quoted in R. V. Gindertael, *Nicolas de Staël* (Basel: Galerie Beyeler, 1966). **214:** Clyfford Still to Mark Rothko, quoted in John P. O'Neill, ed., *Clyfford Still* (New York: Metropolitan Museum and Abrams, 1980). **216:** Augustus Vincent Tack to John Kraushaar, Aug. 8, 1922, quoted in Leslie Furth, *Augustus Vincent Tack: Landscape of the Spirit* (Washington, D.C.: Phillips Collection, 1993). **218:** Mark Tobey, "Japanese Traditions and American Art," *College Art Journal* 18 (Fall 1958). **220:** George Dennison letter, Dec. 1970, reprinted in Jeanne Chenault's essay in *Bradley Walker Tomlin: A Retrospective View* (Buffalo, N.Y.: Buffalo Fine Arts Academy, 1975). **222:** Duncan Phillips, *The Artist Sees Differently* (New York: Weyhe, 1931). **224:** Paul Signac, diary entry from 1898, first edited by John Rewald in *La Gazette des Beaux-Arts* (Apr. 1952), quoted in John Russell, *Vuillard* (Greenwich, Conn.: New York Graphic Society, 1971). **226:** Thadée Natanson, "Vuillard as I Knew Him," *Peints à leur tour*, 1948, quoted in John Russell, *Vuillard*. **228:** Duncan Phillips, "J. Alden Weir," *Art Bulletin* 2 (June 1920). **230:** James Abbott McNeill Whistler, *The Gentle Art of Making Enemies* (New York: 1893), reprinted in Robert Goldwater and Marco Treves, eds., *Artists on Art* (New York: Pantheon, 1972).